GAUDIER-BRZESKA

BY EZRA POUND

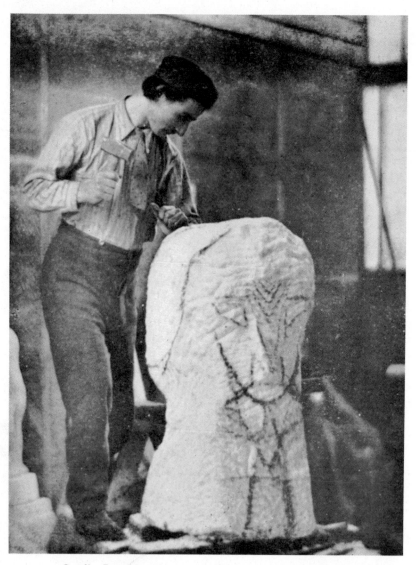

Gaudier-Brzeska working at the Hieratic Head of Ezra Pound.

GAUDIER-BRZESKA

A Memoir

EZRA POUND

A NEW DIRECTIONS BOOK

Manufactured in the United States of America
First published as New Directions Paperbook 372 (ISBN: 0–8112–0527–4) in 1974
Published in Canada by McClelland & Stewart Ltd.

New Directions Books are published for James Laughlin
by New Directions Publishing Corporation
333 Sixth Avenue, New York 10014

FOREWORD TO THIS EDITION

The first edition of this book emphasized a few of Gaudier's modes of work.

Now that a fuller knowledge is available it falls into place as a footnote on what was visible to one spectator in 1913 and '14.

E.P.

' Gli uomini vivono in pochi e gli altri son pecorelle.'
NICCOLO MACHIAVELLI

' Dès l'instant qu'il (le prince) aura attiré près de lui tous les savans et les artistes, aussitot ses richesses seront suffisamment mises en usage.'
The ' Tchoung-Young ' of CONFUCIUS,
traduit par M. G. PAUTHIER

We are grateful to Mme. J. Auzas-Pruvost of the Musée des Beaux-Arts d'Orléans, Sig. Vanni Scheiwiller, Mr. H. S. Ede, Mr. J. Wood Palmer of the Arts Council and the Editor of *Le Jardin des Arts* for the loan of blocks and photographs.

We also wish to thank Sig. Boris de Rachewiltz for the photographs reproduced in Plates XIII, XIV, XXIII(A) and XXIV(A), which he made specially for this edition.

E. P.

CONTENTS

LIST OF ILLUSTRATIONS

I

GAUDIER-BRZESKA

In *Blast* for July, 1915, appears the brief notice:—

"MORT POUR LA PATRIE.

"*Henri Gaudier-Brzeska: after months of fighting and two promotions for gallantry, Henri Gaudier-Brzeska was killed in a charge at Neuville St. Vaast, on June 5th, 1915.*"

It is part of the war waste. Among many good artists, among other young men of promise there was this one sculptor already great in achievement at the age of twenty-three, incalculably great in promise and in the hopes of his friends.

I have known many artists. I am not writing in a momentary fit of grief or of enthusiasm. I am not making phrases. I am not adding in any way to statements I had made and printed during Gaudier's lifetime. A great spirit has been among us, and a great artist is gone. Neither the man nor the artist had shown any traces of failure. Neither do I write in a spirit that is not common to those who had known him; to those who had known him even slightly.

Ford Madox Hueffer in *The Outlook*, for July 31st, has written as follows:—

"I am not at this moment engaged in appraising *Blast* as an achievement. But even to denizens of the stars it must be evident that *Blast* is an adventure, an exploration; and that to refuse to consider where it may possibly get to is to say: 'What fine fellows those yachtsmen, lounging on the pier, are in comparison with the dirty-looking chaps whose ship is visible on the horizon, bound for the North-West Passage.' Indeed, after all the eye-openers critics of the type of my friend must have had, it is amazing that they ever come within ninety miles of an experiment, since any experiment must turn inevitably to red-hot coals in their poor hands and on their poor heads. It is, however, not often that such dire disaster overcomes one of them as has

17

attended the unfortunate friend of mine to whom I now refer.

" One of the finest men that I ever knew was Gaudier-Brzeska. As a sculptor he had carried his experiments far enough to make one say that he was a fine fellow; as a student of his art he had an erudition and a turn of phrase that I have never known equalled. Born in the South of France, Gaudier, at the outbreak of the present war, found himself in England, not having done his military service. He went to Boulogne to offer himself for service; was detained as a technical deserter; escaped, and returned to London; secured a safe conduct from the French Embassy. He went back to France, received a month's training on the Loire, and passed the winter in the trenches. He was twice promoted for gallantry on the field, and was killed in a charge at Neuville St. Vaast on June 5 last.

" Put in this cold language this is a record fine enough—I wish I had it behind me. And it is this man whom my friend the critic selects to pour ridicule upon—pouring, indeed, ridicule upon the very record of his death. That is a rather horrible achievement. I think of poor Gaudier as I last saw him, at a public dinner, standing sideways, with his fine sanguine features, his radiant and tolerant smile, his delicate movements of the hands, answering objection after objection of stimulated, after-dinner objectors to his æsthetic ideas with such a gentleness, with such humour, with such good humour. At that date there was no thought of war; we were just all separating at the end of the London season. And within a year this poor, fine, beautiful spirit has gone out through a little hole in the high forehead."

The journalistic squabbles to which Mr. Hueffer refers further along in the article quoted, do not now much concern us. There remains Gaudier Brzeska's work : some few dozen statues, a pile of sketches and drawings, and a few pages about his art. I am not particularly anxious to make this book " my book " about Gaudier-Brzeska. I am not over-anxious to enter upon long quibbles either about his work or the group-name he chose to work under. The fact remains that he chose to call himself a " vorticist," as Wyndham Lewis, and myself, and Edward Wadsworth and several others have chosen, for good reasons enough. The name does not imply any series of subordinations, it means simply that we were in agreement concerning certain funda-

mentals of art. In so far as a knowledge of our agreement is likely to lead to a clearer understanding or a swifter comprehension of Brzeska's work, in just so far will the general topic of vorticism be dragged into the present work.

Among his latter wishes was the wish that his work should be, in case of his death, made accessible to other artists. (Concerning the general public he said nothing whatever.) Some examples of his work will be placed in the South Kensington Museum, others, we hope, in the Musée du Luxembourg, and still another group of statues will be kept together in Mr. John Quinn's great modern collection.

The work must, in any case, be separated, and it is obvious that all of it cannot be, in the original, accessible to all students of sculpture. Photographs of sculpture are unsatisfactory but they are better than nothing. They are perhaps better than casts, especially in the case of a sculptor who held so much by his material, who never cut in one sort of stone a work more fitting another sort, and who cut direct, when he had the marble or alabaster, or even the metal.

In undertaking this book I am doing what little I can to carry out his desire for accessibility to students, and I am, moreover, writing it very much as I should have written it if he had lived, save that I have not him leaning over my shoulder to correct me and to find incisive, good-humoured fault with my words. (For I should in any case have written some sort of book upon vorticism, and in that book he would have filled certain chapters.)

I have never held with outside criticism, and I have never held much with theories, but it is nonsense to say that great artists do not theorize or that they do not talk *about* art. With the examples of Dante, and Whistler, and Leonardo before us it is nonsense even to say that they do not write about art.

I shall try to give, first, Gaudier's own expressions of his æsthetic belief, and then some account of the man as we knew him, with some citations from his more recent letters, and then some further discussions of art.

If this entails a certain formal and almost dreary documentation at the very outset, I must ask the reader's indulgence. I am trying to leave as clear a record as possible of Gaudier's art and thought.

19

I do not believe that there is any important art criticism, any important criticism of any particular art, which does not come *originally* from a master of that art. If a man spend all his life, all his intensest life, putting sweet sounds together, he will know more about music than a man who is merely pleased by an occasional tune *en passant*. If he spend his life with thoughts of form, or with thoughts of words, he will know more of form or of words, or of colours or whatever it may be, than will the tyro or the dilettante or the incapable observer.

The observer may know the good he cannot perform, the performer may know a good beyond his attainment, but if he have that double capacity both for speculation and for action, he will have perforce an intimacy and a swift moving apprehension, which the sterile observer has not. It is true that many good artists are incapable of talking about their art comprehensibly, or of talking sensibly, or even of talking at all, but the really great artists have seldom been without this faculty for generalization, or without at least a faculty of so speaking as to cast shafts of light into the outsider's comprehension of the degrees of their art.

That Gaudier-Brzeska had an amazing faculty for synthesis was well known to his friends and must be at once apparent to any one who will study his first written formulation of sculptural principles, to wit his first " Vortex," which I reprint here, as it appeared in *Blast* for June, 1914.*

GAUDIER-BRZESKA VORTEX

Sculptural energy is the mountain.

Sculptural feeling is the appreciation of masses in relation.

Sculptural ability is the defining of these masses by planes.

The PALEOLITHIC VORTEX resulted in the decoration of the Dordogne caverns.

Early stone-age man disputed the earth with animals.

His livelihood depended on the hazards of the hunt—his greatest victory the domestication of a few species.

Out of the minds primordially preoccupied with animals

* An article by Gaudier-Brzeska appeared in the *Egoist* about a week earlier, but the " Vortex " was written first.

Fonts-de-Gaume gained its procession of horses carved in the rock. The driving power was life in the absolute—the plastic expression the fruitful sphere.

The sphere is thrown through space, it is the soul and object of the vortex—

The intensity of existence had revealed to man a truth of form—his manhood was strained to the highest potential—his energy brutal—HIS OPULENT MATURITY WAS CONVEX.

The acute fight subsided at the birth of the three primary civilizations. It always retained more intensity East.

The HAMITE VORTEX of Egypt, the land of plenty—

Man succeeded in his far reaching speculations—Honour to the divinity!

Religion pushed him to the use of the VERTICAL which inspires awe. His gods were self made, he built them in his image, and RETAINED AS MUCH OF THE SPHERE AS COULD ROUND THE SHARPNESS OF THE PARALLELOGRAM.

He preferred the pyramid to the mastaba.

The fair Greek felt this influence across the middle sea.

The fair Greek saw himself only. HE petrified his own semblance.

HIS SCULPTURE WAS DERIVATIVE his feeling for form secondary. The absence of direct energy lasted for a thousand years.

The Indians felt the hamitic influence through Greek spectacles. Their extreme temperament inclined towards asceticism, admiration of non-desire as a balance against abuse produced a kind of sculpture without new form perception—and which is the result of the peculiar

VORTEX OF BLACKNESS AND SILENCE.

PLASTIC SOUL IS INTENSITY OF LIFE BURSTING THE PLANE.

The Germanic barbarians were verily whirled by the mysterious need of acquiring new arable lands. They moved restlessly, like strong oxen stampeding.

The SEMITIC VORTEX was the lust of war. The men of Elam, of Assur, of Bebel and the Kheta, the men of Armenia and those of Canaan had to slay each other cruelly for the possession of fertile valleys. Their gods sent them the vertical direction, the earth, the SPHERE.

They elevated the sphere in a splendid squatness and created the HORIZONTAL.

From Sargon to Amir-nasir-pal men built man-headed bulls in horizontal flight-walk. Men flayed their captives alive and erected howling lions : THE ELONGATED HORIZONTAL SPHERE BUTTRESSED ON FOUR COLUMNS, and their kingdoms disappeared.

Christ flourished and perished in Yudah.

Christianity gained Africa, and from the seaports of the Mediterranean it won the Roman Empire.

The stampeding Franks came into violent contact with it as well as the Greco-Roman tradition.

They were swamped by the remote reflections of the two vortices of the West.

Gothic sculpture was but a faint echo of the HAMITO-SEMITIC energies through Roman traditions, and it lasted half a thousand years, and it wilfully divagated again into the Greek derivation from the land of Amen-Ra.

VORTEX OF A VORTEX!!

VORTEX IS THE POINT ONE AND INDIVISIBLE!

VORTEX IS ENERGY! and it gave forth SOLID EXCRE-MENTS in the quattro e cinque cento, LIQUID until the seventeenth century, GASES whistle till now. THIS is the history of form value in the West until the FALL OF IMPRES-SIONISM.

The black-haired men who wandered through the pass of Khotan into the valley of the YELLOW RIVER lived peace-fully tilling their lands, and they grew prosperous.

Their paleolithic feeling was intensified. As gods they had themselves in the persons of their human ancestors—and of the spirits of the horse and of the land and the grain.

THE SPHERE SWAYED.

THE VORTEX WAS ABSOLUTE.

The Shang and Chow dynasties produced the convex bronze vases.

The features of Tao-t'ie were inscribed inside of the square with the rounded corners—the centuple spherical frog presided over the inverted truncated cone that is the bronze war drum.

THE VORTEX WAS INTENSE MATURITY. Maturity is fecundity—they grew numerous and it lasted for six thousand years.

The force relapsed and they accumulated wealth, forsook their work, and after losing their form-understanding through the Han and T'ang dynasties, they founded the Ming and found artistic ruin and sterility.

THE SPHERE LOST SIGNIFICANCE AND THEY ADMIRED THEMSELVES.

During their great period off-shoots from their race had landed on another continent. After many wanderings some tribes settled on the highlands of Yukatan and Mexico.

When the Ming were losing their conception, these neo-Mongols had a flourishing state. Through the strain of warfare they submitted the Chinese sphere to horizontal treatment much as the Semites had done. Their cruel nature and temperament supplied them with a stimulant: THE VORTEX OF DESTRUCTION.

Besides these highly developed peoples there lived on the world other races inhabiting Africa and the Ocean islands.

When we first knew them they were very near the paleolithic stage. Though they were not so much dependent upon animals their expenditure of energy was wide, for they began to till the land and practice crafts rationally, and they fell into contemplation before their sex: the site of their great energy: THEIR CONVEX MATURITY.

They pulled the sphere lengthways and made the cylinder, this is the VORTEX OF FECUNDITY, and it has left us the masterpieces that are known as love charms.

The soil was hard, material difficult to win from nature, storms frequent, as also fevers and other epidemics. They got frightened: This is the VORTEX OF FEAR, its mass is the POINTED CONE, its masterpieces the fetishes.

And WE the moderns: Epstein, Brancusi, Archipenko, Duni-

kowski, Modigliani, and myself, through the incessant struggle in the complex city, have likewise to spend much energy.

The knowledge of our civilization embraces the world, we have mastered the elements.

We have been influenced by what we liked most, each according to his own individuality, we have crystallized the sphere into the cube, we have made a combination of all the possible shaped masses—concentrating them to express our abstract thoughts of conscious superiority.

Will and consciousness are our
VORTEX.

II.

GREAT artists have often, as I have said above, possessed a faculty for synthesis. They have cast shafts of light from their conversation, but we are not always lucky enough to have a record of that conversation, or any full synthesis left us. J. M. Synge would have been a great genius, but I doubt if he would have written his plays, or at least so many plays, if there had not been a small, much reviled theatre in Dublin. Gaudier-Brzeska's sculpture would have been just what it was, even if there had been no " vorticist movement," but the still exasperated public would never have had this splendid formulation of his views, this " whole history of sculpture," if there had not been a periodical edited by Wyndham Lewis, or if the very terms " vortex " and " vorticism " had not been given him as " a peg for his thought."

One cannot ask Mr. Synge's admirers to like Mr. Yeats, one does not seek to bring the admirers of Gaudier-Brzeska to the feet of either Mr. Lewis or myself, but when I see in the Press statements to the effect that Gaudier was not a vorticist, or that I am not a vorticist, I am compelled to think that the writers of such statements must have read into the term " vorticism " some meaning which is not warranted by our meanings and our definitions. At no time was it intended that either Mr. Lewis, or Gaudier or myself or Mr. Wadsworth or Mr. Etchells should crawl into each other's skins or that we should in any way surrender our various identities, or that the workings of certain fundamental principles of *the arts* should force any one of us to turn his own particular *art* into a flat imitation of the external features of the particular art of any other member of our group.

For the second number of *Blast,* Gaudier had planned an essay on " The Need of Organic Forms in Sculpture." It was in almost our last long talk that he outlined his position. He had made Mr. Hulme's " toy," the best of several purely geometric abstractions, cut straight into brass. He had further experimented with almost the same forms for a couple of cut-brass door-knockers. He had done the " Bird swallowing a fish "

25

which appears in the photo of him (plate XX); he had cut a very small brass fish for Mrs. Kibblewhite. His conclusion, after these months of thought and experiment, was that combinations of abstract or inorganic forms exclusively, were more suitable for painting than for sculpture. Firstly, because in painting one can have a much greater complexity, a much greater number of form units than in sculpture. In sculpture the main composition must be simpler. At least the outline from any one point of view must be simpler than the gross conglomeration of forms in a painting; in, say, one of the more complex designs of Lewis' " Timon."

Secondly. The field for combinations of abstract forms is nearly unexplored in occidental painting, whereas machinery itself has used up so many of the fine combinations of three dimensional inorganic forms that there is very little use in experimenting with them in sculpture.

I am afraid that is a very rough and clumsy statement of something he would have put much more clearly.

Needless to say the forms of automobiles and engines, where they follow the lines of force, where they are truly expressive of various modes of efficiency, can be and often are very beautiful in themselves and in their combinations, though the fact of this beauty is in itself offensive to the school of sentimental æsthetics.

Good generalization, or good criticism, in the arts, invariably *follows* performance. Gaudier had already demonstrated the soundness of his instinct for the combination of organic with inorganic forms in such works as the " Stags " and " The Boy with a Coney." These and certain works have in them what Lewis has called " Brzeska's peculiar soft bluntness." No two men were ever less likely to imitate each other, or less likely to suffer mutual jealousy than these two artists of such very distinct, very different genius. No two men were quicker to see the good in each other's work, despite irritations, as we shall prove later from Gaudier's own critique.

In the meantime the essay on " The Need of Organic Forms " was left unwritten. Louvain was burned, Rheims was shelled. Gaudier went off to Le Havre, drilled, went to the front some time in September, wrote several letters which I shall quote from later, and wrote another vortex for *Blast*. As follows :—

VORTEX GAUDIER-BRZESKA

(Written from the Trenches.)

Note.—The sculptor writes from the French trenches, having been in the firing line since early in the war.

In September he was one of a patrolling party of twelve, seven of his companions fell in the fight over a roadway.

In November he was nominated for sergeancy and has been since slightly wounded, but expects to return to the trenches.

He has been constantly employed in scouting and patrolling and in the construction of wire entanglements in close contact with the Boches.

I HAVE BEEN FIGHTING FOR TWO MONTHS and I can now gauge the intensity of life.

HUMAN MASSES teem and move, are destroyed and crop up again.

HORSES are worn out in three weeks, die by the roadside.

DOGS wander, are destroyed, and others come along.

WITH ALL THE DESTRUCTION that works around us NOTHING IS CHANGED, EVEN SUPERFICIALLY. LIFE IS THE SAME STRENGTH, THE MOVING AGENT THAT PERMITS THE SMALL INDIVIDUAL TO ASSERT HIMSELF.

THE BURSTING SHELLS, the volleys, wire entanglements, projectors, motors, the chaos of battle DO NOT ALTER IN THE LEAST the outlines of the hill we are besieging. A company of PARTRIDGES scuttle along before our very trench.

IT WOULD BE FOLLY TO SEEK ARTISTIC EMOTIONS AMID THESE LITTLE WORKS OF OURS.

THIS PALTRY MECHANISM, WHICH SERVES AS A PURGE TO OVER-NUMEROUS HUMANITY.

THIS WAR IS A GREAT REMEDY.

IN THE INDIVIDUAL IT KILLS ARROGANCE, SELF-ESTEEM, PRIDE.

IT TAKES AWAY FROM THE MASSES NUMBERS UPON NUMBERS OF UNIMPORTANT UNITS, WHOSE ECONOMIC ACTIVITIES BECOME NOXIOUS AS THE RECENT TRADES CRISES HAVE SHOWN US.

MY VIEWS ON SCULPTURE REMAIN ABSOLUTELY THE SAME.

IT IS THE VORTEX OF WILL, OF DECISION, THAT BEGINS.

I SHALL DERIVE MY EMOTIONS SOLELY FROM THE ARRANGEMENT OF SURFACES, I shall present my emotions by the ARRANGEMENT OF MY SURFACES, THE PLANES AND LINES BY WHICH THEY ARE DEFINED.

Just as this hill where the Germans are solidly entrenched, gives me a nasty feeling, solely because its gentle slopes are broken up by earth-works, which throw long shadows at sunset. Just so shall I get feeling, of whatsoever definition, from a statue ACCORDING TO ITS SLOPES, varied to infinity.

I have made an experiment. Two days ago I pinched from an enemy a mauser rifle. Its heavy unwieldy shape swamped me with a powerful IMAGE of brutality.

I was in doubt for a long time whether it pleased or displeased me.

I found that I did not like it.

I broke the butt off and with my knife I carved in it a design, through which I tried to express a gentler order of feeling, which I preferred.

BUT I WILL EMPHASIZE that MY DESIGN got its effect (just as the gun had) FROM A VERY SIMPLE COM-POSITION OF LINES AND PLANES.

 GAUDIER-BRZESKA.

This essay was written in pencil, and on the corner of the sheet is the further message—

" I have been slightly wounded in the night of Sunday 8th, on patrol duty, I have been at rest since and am returning service within two or three days."

Mr. Hueffer, quoting the foregoing essay in his *Outlook* article introduces it as follows :—

" I do not think you can want anything gentler or wiser as an expression of artistic ideals." And he says later : " I find that a very touching and wise passage of prose. And I will ask the reader to observe that it contains the thoughts of an artist who had a mystical and beautiful mind and who had been long under fire. Is it not interesting and valuable to observe what

such a mind selects? If *Blast* had presented us with nothing else it would have been justified in its existence."

I spoil Mr. Hueffer's tribute by quoting it in fragments, but it interests me because Mr. Hueffer was, as I thought, more particularly interested in contemporary painting than in sculpture, whereas some of us were at first more interested in sculpture, which seems, in one sense, peculiarly a thing of the twentieth century. No, acrimonious reader, do not seize that last clause by itself; let me explain what I mean. Sculpture, of this new sort, Epstein's, Brzeska's, is perhaps more moving than painting simply because there has been for centuries no sculpture that one could take very seriously. There was the early work of Rodin, a beginning. But with that partial exception we must go back to the polychrome portrait effigies of the early renaissance, or to the medals of that period, before we discover anything that can move us. It is therefore exciting and interesting to find Epstein and Brzeska doing work that will bear comparison with the head of " An officer of rank " (of the XVII to XVIII dynasty); with Egyptian stone and with the early Chinese bronzes. Not that you would have pleased either of the two men by making comparisons in a hurry, or by endeavouring to express the precise shade of your pleasure in their work with the terminology derived from antiquity. At least Epstein reproved me vigorously for comparing some quality in his " Birds " to some analogous quality in a great stone scarab, and Brzeska resented the label " Chou " in my criticism of a show at the Goupil Gallery,* even though I had prefixed the term with qualifications. Thus: " it is no use saying that Epstein is Egyptian and that Brzeska is Chinese. Nor would I say that the younger man is a follower of the elder. They approach life in different manners. . . . Of the two animal groups his (Brzeska's) stags are the more interesting if considered as a composition of forms. ' The Boy with the Coney ' is ' Chou ' or suggests slightly the bronze animals of that period. Brzeska is as much concerned with representing certain phases of animal life as is Epstein with presenting some austere permanence; some relation *of* life and yet outside it. It is as if some realm of

* Appearing in the *Egoist*, March 16th, 1914.

' ideas ', of Platonic patterns, were dominated by Hathor."

Brzeska takes up my mild allusion with considerable vigour in his critique entitled, " The Allied Artists' Association Ltd.," which appeared in the *Egoist* three months later. It is a review of a show at Holland Park Hall, and was asked for, I think, by Richard Aldington during a lull in their (his and Brzeska's) perpetual, acrimonious, and fundamentally amical dispute as to whether Greek art and civilization were worthy of serious consideration. Aldington being all for " Hellas," and Brzeska's refrain, " Those *damn* Greeks."

I give the article entire, for it is a valuable presentation of Brzeska's position with regard to other contemporary artists. I have underlined his paragraph about Lewis, firstly, because I wish to refer to it later, and secondly because it settles a quibble which has been raised in the Press, and clearly marks Brzeska's opinion of certain vorticist paintings.

ALLIED ARTISTS' ASSOCIATION LTD., HOLLAND PARK HALL
By Henri Gaudier-Brzeska

I am in a perilous position. I am on the year's staff of the association, an exhibitor and the personal friend of many artists who show their works. In some quarters I am supposed to write an official whitewashing account; many readers will accuse me of self-adulation and praising of a sect—for all these people I have the greatest contempt.

Sculpture

I specially begin with this virile art. The critics as a whole ignore it—place it always last—excusing themselves by the kind sentence : " It is not lack of good-will but lack of space which prevents me from," etc., etc. They also prate endlessly about sculpture being separated from her mother art : Architecture— poor child ! If they had not lost their manhood they would find that sculpture and architecture are one and the same art. On many occasions sculptors have erected buildings to place their statues. On many occasions artists like Epstein, Brancusi and myself would easily build palaces in harmony with their statuary.

The architecture that would result would be quite original, new, primordial. A professional critic's mind cannot see beyond vile revivals of Greco-Roman and Gothic styles. A professional critic when organizing a provincial exhibition catalogues the "group in red alabaster" of one man as the "group in white marble" of another—it proves their omniscience.

The sculpture I admire is the work of master craftsmen. Every inch of the surface is won at the point of the chisel—every stroke of the hammer is a physical and mental effort. No more arbitrary translations of a design in any material. They are fully aware of the different qualities and possibilities of woods, stones, and metals. Epstein, whom I consider the foremost in the small number of good sculptors in Europe, lays particular stress on this. Brancusi's greatest pride is his consciousness of being an accomplished workman. Unfortunately Epstein, who has been a constant exhibitor at the A.A.A. is absent this year. A work in marble by Brancusi is catalogued, but up to the present it has not arrived. It is a great pity, for I intended to dwell at length on the merits of this statue. The number of people who are at all furthering their scuptural expression is thus reduced to Zadkin and myself.

ZADKIN

is contributing two works in wood—another in stone. I prefer the wooden head. We have here a composition of masses moving in three concentric directions. To be especially admired is the contrast of the deeply undercut hair mass to the undulated surface of the shoulders. This head would be a masterpiece were it not a little spoilt by a very sweet expression. The technique is beautiful—a quality of surface which is seldom seen in wood. The other wood "composition" is far less satisfactory—it is also sentimental, which spoils the general effect. We get in the stone group "Holy Family" the same heads again—in two instances but in very low relief—half the group is thus tinged with insipidity. A corner of it is well cut and very serene. On the whole Zadkin is pulled between a very flowing, individual conception of form—which some artists call "lack of form"—and which has the power of emanating great life——and a very strong liking for pretty melancholy—which bores me.

GAUDIER-BRZESKA

I have on show " a boy with a coney " which has been referred to in these columns* as an echo of the bronze animals of the Chow dynasty. It is better than they. They had, it is true, a maturity brought by continuous rotundities—my statuette has more monumental concentration—a result of the use of flat and round surfaces. To be appreciated is the relation between the mass of the rabbit and the right arm with that of the rest. The next is a bird. Unfortunately I now see that had the planes of the wings been convex and the forepart thicker the design would have gained in buoyancy and stateliness. The design in alabaster creates an emotion of distinguished melancholy. The design in green marble one of intense reptile life. The door-knocker is an instance of an abstract design serving to amplify the value of an object as such. No more cupids riding mermaids, garlands, curtains—stuck anywhere! The technique is unusual; the object is not cast but carved direct out of solid brass. The forms gain in sharpness and rigidity.

The rest of the sculpture is an agglomeration of Rodin-Maillol mixture and valueless academism—with here and there some one trying to be naughty : curled nubilities and discreet slits.

PAINTING

Lewis's most important work had not arrived when I wrote this. I propose to write another article dealing with it and Brancusi's statue if it comes. Wyndham Lewis has made enormous progress in his painting. The two small abstractions " Night Attack " and " Signalling " are such very complete individual expressions that no praise is sufficient to adequately point out their qualities. These are designs of wilful, limited shapes contained in a whole in motion—and this acquired with the simplest means—ochres and blacks. Lewis's abstractions are of a decided type and their composition is so successful that I feel right in seeing in them the start of a new evolution in painting.

WADSWORTH

is well represented by a " short flight " : a composition of cool tones marvellously embodied in revolving surfaces and masses.

* *Egoist.*

His bigger picture, No. 113, gives more pleasure on account of the warmer pigments used and the construction : growing in a corner and balanced at the other by a short mass.

PHELAN GIBB

is hung next to Wadsworth, which makes its poor amorphism and lack of design appear the more. A really poor kind of abstraction half-way between Kandinsky and Picasso of the early stages.

KANDINSKY

presents an " improvisation," a " picture with yellow colouring," and a third, No. 1559. I have been told that he is a very great painter, that his lack of construction is a magnificent quality, that he has hit something very new. Alas, I also know all his twaddle " of the spiritual in art." I agree that these colours—set free, so to speak—have an effect of mirth. This is a very slight emotion nevertheless. My temperament does not allow of formless, vague assertions, " *all what is not like me is evil* "; so is Kandinsky.

A. DE SOUZA CARDOSO

comes nearer to my feelings. He has as much colour as Kandinsky and of a richer kind in his " musicien de nuit." Whereas Kandinsky always uses the same palette—at least in his works here—Cardoso tones it down to a perfection in his " jardinier," a jewel of warm blues agitated in a fresh motion.

KARL HAGEDORN

offers the worst instance of feelingless abstraction—no emotions; no art.

NEVINSON,

a futurist painter. It is impressionism using false weapons. The emotions are of a superficial character, merging on the vulgar in the " syncopation "—union jacks, lace stockings and other tommy rot. The coloured relief is at least free from this banality —yet there are ciphers and letters—and though the whole is in good movement I do not appreciate it.

People like Miss Dismorr, Miss Saunders and Miss Jones are well worth encouraging in their endeavours towards the new light. With them stops the revolutionary spirit of the exhibition.

Before dealing with the rest of the paintings I make a digression among applied art. The Rebel art centre has a stand. The Omega Shops have the lounge. The Rebel stand is in unity. A desire to employ the most vigorous forms of decoration fills it with fans, scarves, boxes and a table, which are the finest of these objects I have seen.

The spirit in the lounge is one of subtlety. I admire the black and white carpet—the inlaid tables and trays, the pottery. The chairs, the cushions and especially a screen with two natural swans and the hangings of patched work irritate me—there is too much prettiness.

Happily the Rebel stand shows that the new painting is capable of great strength and manliness in decoration.

Though I am not wholly in sympathy with the other painters, I feel it my duty to point out that the rest of the hall is shared by two sections—one composed of able, convinced men admiring natural forms only—and the other of poor academic imitators whose efforts cannot be classified as art even.

There is a transitional body—men starting from nature and g tting on the verge of the abstract.

WOLMARK

His two negroes handling carpets make a fine composition. The not so violent colours as usual, the good workmanship, and intensified drawing make of it his best work so far. His smaller " negro " of duller tones yet, is also very successful. Wolmark argues that his representation helps to receive the emotion purported by the design. This is a difficult question—it must be candidly said that this form of art can co-exist with absolute abstraction and fill one with pleasure.

MISS ROWLEY LEGGETT

in her reclining woman shares apparently the same view. Her colours are fresh and transparent, and as the expression, the human interest at large is very secondary to the composition I like it very much.

HORACE BRODZKY

sends an able " still life " and a " portrait "—the colours are very warm but here I feel the representation to have become the

34

primary quality. A fault of which I accuse the painter is of preferring harsh contrast. A quality I find is his great frankness.

Miss Hammett

cares much about representation. It is very interesting to see a portrait of Zadkin, the wood-carver. In this work there are great technical qualities of paste and drawing—more amplified in the other portrait—where carefully chosen blacks and violets create a very distinguished effect. I see from the qualities of the " women composition " that the affinities of this artist are coming nearer to a preference for abstract design.

Mme. R. Finch

has a good portrait. The greens and reds are finely tempered by the qualities of the face. I recognize here a greater talent than I have ever met in a woman artist. The " Reginald " unhappily does not rank so high as this masterly little head.

Then come the artists more or less closely bound with the Camden Town Group.

Mme. Karlowska

has a good picture—a happy composition of figures in a half-circle—figures of secondary importance to the composition—and a great relief with it, the absence of pink atmosphere.

Bevan

has " horses "—also an original composition—crossing the surface of the picture at an angle with two contrary movements balanced by a globular crowd. I believe greater enjoyment would be derived from its colours and arrangement had Bevan done away with the notion that he saw horses and men.

Gilman

works very solidly. His " Norwegian Scene " has a fine construction. The colours are fresh, the effect very natural and spontaneous, the technique accomplished.

Ginner

possesses very much the same qualities in his works—his manner of working is not so loose—he loses by it in spontaneity; he gains in completeness.

I am very sorry to say that I don't agree with these two painters' ideas of realism—and grieved to see no hope for them.

AN OPEN LETTER

Perhaps for the sake of an almost philological completeness I had better include also an open letter to the *Egoist*. The dispute with " Auceps " need not be taken too solemnly. It was part of the discussion about " those *damn* Greeks." Auceps was, in part, out for a lark. It was perhaps a lark plus a little asperity.

Gaudier's letter was preceded by one from myself in which I had used the phrase :

" Let us confess that we have derived more pleasure from the works of Wyndham Lewis than from the works of Poussin and Apelles."

We had bet that Auceps would reply to this by pointing out that works of Apelles no longer survived the wear of time, and Auceps gratified us by doing so in the next number of the *Egoist, with italics.*

Gaudier's letter was as follows : —

To the Editor, The Egoist.*

Madam,

I wish to answer the impertinent " Auceps " on the question of new sculpture which he treats with so much contempt. The young gentleman seems to have just left a high school and coming in contact with life he is unable to fathom the depth of artistic earnest—therefore this desperate brandishment of false and arrogant scholastics. If he had entered into the spirit of " logic Greek philosophy " he might have found even there that only the very ignorant try to refute by means of ridicule and irony. No fair-minded person can form an opinion upon the value of such a statement as his, which even relies upon a few French locutions to get acuteness of derision. This much for this aspect of the writer's personality, which I despise. Let us to the Greeks :

The archaic works discovered at Gnossos are the expressions of what is termed a " barbaric " people—i.e., a people to whom reason is secondary to instinct. The pretty works of the great

* *Egoist,* March 16th, 1914.

Hellenes are the productions of a civilised—i.e., a people to whom instinct is secondary to reason.

The enormous differences advocated in favour of these sculptors : Scopas, Praxiteles, Pheidias, Lysippos, Polykleites, Paionios and Myron, I suppose, are at the most differences in tendency—such as between Praxiteles and Pheidias, the former laying stress upon juvenile and morbid gracefulness, the latter upon broad, manly firmness of composition—in general, differences in temperament as existed between Lysippos and Polykleites. Such differences can always be observed among men who are agreed upon any theory. This can be seen in the bosom of the Royal Academy to-day. Let Auceps compare the works of the different sculptors of this institution : a Sir George Frampton statue has many points of divergence from a Howard Thomas, say.

What Auceps bitterly calls the " ithyphallic " (or some other word sounding like it and which I do not understand) sculptors of to-day differ from these later Greeks not in tendency but in *kind,* and Auceps brings upon his head the weight of ridicule by judging these recent works with, as a standard, the superficial qualities of the late Greeks. It would be better if he had the courage to say, " I am a dry intellect and I can *understand* but *to feel* is impossible."

The modern sculptor is a man who works with instinct as his inspiring force. His work is emotional. The shape of a leg, or the curve of an eyebrow, etc., etc., have to him no significance whatsoever; light voluptuous modelling is to him insipid—what he feels he does so intensely and his work is nothing more nor less than the abstraction of this intense feeling, with the result that sterile men of Auceps' kind are frightened at the production. That this sculpture has no relation to classic Greek, but that it is continuing the tradition of the barbaric peoples of the earth (for whom we have sympathy and admiration) I hope to have made clear.

London. H. GAUDIER-BRZESKA.

That, I think, completes the reprint of Gaudier's prose publications, as they appeared in *Blast* for June 20th, 1914, and for July, 1915, and in the *Egoist* for March 16th and June 15th,

1914, to the Editors of which periodicals I wish to make due acknowledgment.

And these, with the reproductions of his sculpture and drawings, and with certain excerpts from his letters and one excerpt from a sketch-book, must be all that I can give of the man himself. The rest is perforce impressions and opinion, mine and those of Mr. Benington's camera. And Mr. Benington's camera has the better of me, for it gives the subject as if ready to move and to speak, whereas I can give but diminished memories of past speech and action.

III

The Man

The vivid, incisive manner, the eyes " almost alarmingly intelligent." People will remember him in various divergent manners, but that much at least will be a common recollection. His stillness seemed an action, such was the daemon of energy that possessed him, or served him.

It is because of this activeness, this unremitting need of, or urge to physical activity, that the making of his work accessible to other artists will be almost useless. You may implant his ideas in other artists, you may make him the inspiration of students, even of students of talent and habile copyists, but you will not find another man so combining the faculties of a sculptor. That is to say, by a miracle you might find a man with his sense of stone or his sense of form or a man capable of appreciating his genuine wisdom, but to combine these with an apparently inexhaustible manual activity, No !

It is one thing to conceive a statue, even to conceive, with extreme precision its numberless outlines and planes, it is quite another thing to transfer it to " implacable " stone. Without these two faculties in conjunction nothing worth calling sculpture is produced.

Thus we remember Gaudier, on the brink of a chair, as if on the verge of departure; the verge might last a couple of hours, a flow of remarks jabs the air.

" No, he told me the whole history of Poland, in half an hour, with a sketch of the constitution. It was very interesting."

That sort of thing was always happening. It was always interesting : so far as I was concerned it was never the history of Poland. It was always something different, it was always interesting. You always felt that the subject of the conversation was exhausted, that there was nothing more to say, that you might read numerous and voluminous works and learn nothing more of importance.

It might be exogamy, or the habits of primitive tribes, or the

39

training of African warriors, or Chinese ideographs, or the disgusting "mollesse" of metropolitan civilization, or abundant chaff, or æsthetics.

Or you had him arriving, possibly from Putney, with four small statues in his various "pockets" and three more of considerable weight slung on his back in a workman's straw basket . . . and half of them lent you for a week or so, so that your rooms were, for the time, rich as a palace.

And, as if his walks, his prowlings, his constant chipping at stone were not enough to occupy his hands and feet, he made his own tools at a forge. It might take a full day to temper his chisels. These chisels were made from old steel spindles sent him by Mr. Dray, who had, or perhaps still has, a factory somewhere in the indefinite "North." This also may have been an economy, but it was the sort of economy Gaudier liked. He liked to do the "whole thing" from start to finish; to feel as independent as the savage.

It is possibly from the use of his forge that he took it into his head to cut metal rather than cast it. Possibly he wished to escape the cost of having things cast, but I think that unlikely. He forged his tools, he cut stone until its edge was like metal, as for example the charm in green Irish marble. The softness of castings displeased him and so he cut the brass direct. The charm he wore for some weeks suspended from his neck by a string.

That is the way memory serves us, details return ill assorted, pell mell, in confusion.

IV

PIECING together Gaudier's early biography from Miss Brzeska's data, I find that he was born at St. Jean de Braye, Loiret, on October 4th, 1891. He was the son of Joseph Gaudier, a joiner. Henri respected his father because he was a good workman with some pride in his craft and because le père Gaudier had made a fine door or doorway for some place or other in Loiret.

At fourteen Henri Gaudier won a small scholarship which took him to London. Then he was in school at Orleans and won another scholarship over a great number of competitors from all France. This took him to Bristol College.

At Bristol he satisfied his professors, refused some sort of an offer of patronage, and was finally sent to Germany to study art at the expense of the college.

His note-books begin with very detailed studies of birds in the museum (? the Bristol museum). He evidently walked about in Somerset. Then, partly on the evidence of the note-books, we know that he went to Nuremberg, and later to Munich, possibly to other cities *en route*.

Later at Paris, partly as the outcome of conversations with a Czech poet, whose name Miss Brzeska has forgotten, and whom he used to meet at the Café Cujas, Gaudier determined to devote himself to sculpture. This brings us to 1910.

A note-book entitled " Le Chaos," begins with the statement, " Ce livre appartient à Henri Gaudier qui se propose de le remplir d'esquisses et de croquis." The first study is " Phidias going to the Acropolis to carve the figures for the Parthenon, monté sur une magnifique bicyclette." The book is full of pen portraits with such titles as " Friponille de Bourgeois," " Sale Russe qui peut la vodka," " Germaniste enragé—grand lecteur des Sagas Scandinaves," " Ombre du Christ et de François ler roy, portrait d'un étudiant en médecine."

The only portrait I recognize is that of Mr. Dray but the book would probably be of considerable personal interest to people who knew Gaudier at that time. It contains also various copies of poems, notably Baudelaire's " Chats puissants et doux."

Another note-book beginning "April 5th, 1911," contains notes on pigment, academic studies of muscles, sketches from Goya.

The book contains what might be considered the germ of his first "Vortex," at least it shows him already considering the dominant characteristics of the different periods of sculpture, with an objection to Egypt because "Mysticisme nuit à la vraie sensation d'art. S'est servie de la sculpture comme d'un instrument pour élever des colosses de granit Témoins de sa philosophie."

The most interesting note in the book is his revolt from "Michael Ange 20 Avril 1911," as follows :
"dessiner dans les plans majeurs les masses principales
 „ „ „ masses „ „ plans mineurs
 „ „ „ plans mineurs „ masses „
et rendre fermes ces masses mineures par l'étude correcte et vraie de tous leurs plans.

"Je crois que cette manière de travailler conduit à un détail magnifiquement véridique mais toujours contenu dans un ensemble imposant, faisant pour ainsi dire cet ensemble même.

"La ligne est une chose purement imaginative, elle ne vient dans le dessin que pour contenir les plans de la masse, recevant la lumière et créant l'ombre, les plans convoient la seule sensation artistique et la ligne ne leur sert que de cadre. L'artiste recherchant la pureté de la ligne et y ajustant les plans erre, il ajuste un tableau à un certain cadre et non un cadre à un certain tableau, c'est pourquoi je hais Ingres, Flaxman et les préraphaélites, et tous les sculpteurs modernes à l'exception de Dalou, Carpeaux, Rodin, Bourdelle et quelques autres."

At this time he calls himself definitely H. Gaudier-Brzeska. The funds from Bristol had run out. He supported himself by doing commercial correspondence and translations, first with the Libraire Collins, where he was badly treated; then with a German firm for Kodak accessories and telescopic gun-sights. Then he made designs for a firm of calico printers. He studied in museums after his working hours. He had also found time to learn short-hand.

Later he went to his parents on the Loire, resumed his painting,

came to London and was for three months out of work. This in 1911, the last sketch-book with the notes in French may have been filled here. He next obtained a clerkship in the city, studied in museums in the evenings and on Saturday afternoons and spent half the night drawing. Then he broke down. Finally he got a little work on advertising designs. He did a large poster for " Macbeth," and several others, which remained, for the most part, unsold.

The first piece of sculpture that he was commissioned to make was the statue of Maria Carmi. I am told he was promised £100 for this work, from people well able to pay it. " They ended by giving him £5."

To give the man as I knew him, there is perhaps no better method, or no method wherein I can be more faithful than to give the facts of that acquaintance, in their order, as nearly as I can remember them.

In reading over what I have written I find it full of conceit, or at least full of pronouns in the first person, and yet what do we, any of us, know of our friends and acquaintance save that on such and such a day we saw them, and that they did or said this, that or the other, to which words and acts we give witness.

A number of people desire some immediate record of Gaudier's work and there is, I think, no one else ready to take the necessary trouble of preparing that record.

I was with O.S. at a picture show in the Albert Hall (" International," " Allied Artists'," or something). We wandered about the upper galleries hunting for new work and trying to find some good amid much bad, and a young man came after us, like a well-made young wolf or some soft-moving, bright-eyed wild thing. I noted him carefully because he reminded me a little of my friend Carlos Williams.

He also took note of us, partly because we paused only before new work, and partly because there were few people in the gallery, and partly because I was playing the fool and he was willing to be amused by the performance. It was a warm, lazy day, there was a little serious criticism mixed in with our nonsense. On the ground floor we stopped before a figure with bunchy muscles done in clay painted green. It was one of a group of interesting things. I turned to the catalogue and began to take liberties with the appalling assemblage of consonants : " Brzxjk——" I began. I tried again, " Burrzisskzk—— " I drew back, breathed deeply and took another run at the hurdle, sneezed, coughed, rumbled, got as far as " Burdidis—— " when there was a dart from behind the pedestal and I heard a voice speaking with the gentlest fury in the world : " Cela s'appelle tout simplement Jaersh-ka. C'est moi qui les ai sculptés."

And he disappeared like a Greek god in a vision. I wrote

at once inviting him to dinner, having found his address in the catalogue. He did not arrive. His sister tells me that she prevailed with him to intend to come, but that there was a row at the last moment and that by the time he had got himself ready it was too late.

The morning after my date I received a letter addressed to me as " Madame," inviting me to the studio. Then a meeting was arranged through a mutual acquaintance. I went to the studio. He came to the Cabaret one evening.

He sold me the marble group and a torse at what would have been a ridiculous figure had it not been that he had next to no market and that I have next to no income. In fact, it was only a bit of unforeseen and unrepeatable luck that enabled me to acquire the statues. Though I must say in deference to my own common sense that even his sister then thought the group unsaleable, and told me later that she believed I only took it out of charity, though it is now recognized as one of the most personal and intense expressions.

He had, if I remember rightly, just finished one torse and was working on the one now at the " South Kensington." Then came the works in veined alabaster, the " Stags " and " The Boy with a Coney." He had not been very long at the studio under the railroad arch in Putney.

I was interested and I was determined that he should be. I knew that many things would bore or disgust him, particularly my rather middle-aged point of view, my intellectual tiredness and exhaustion, my general scepticism and quietness, and I therefore opened fire with " Altaforte," " Piere Vidal," and such poems as I had written when about his own age. And I think it was the " Altaforte " that convinced him that I would do to be sculpted. I do not think he took much stock of any of my poems save those in that book, and a few of the more violent later short satires which have not yet seen the light, though he must have opened my " Ripostes," for I find three drawings on the blank half-pages of his copy, one a study for the bust, and another a fine design for " The Tomb at Acr Caar." " Cathay " he had only later, in the trenches. He even tried to persuade me that I was not becoming middle-aged, but any man whose youth has been worth anything, any man who has lived his life at all in the

sun, knows that he has seen the best of it when he finds thirty approaching; knows that he is entering a quieter realm, a place with a different psychology.

At any rate we had long, gay, electrified arguments over my scepticism as to the impracticability of anarchy, over my disparagements of the benefit of living like African tribesmen, however fine their discipline might be for the individual savage. And upon such latter topics he poured, as I have said above, a flood of detailed information.

Sic: That in such a tribe they give a man most sumptuous wedding presents, but that on the wedding night all the donors combine to steal them back, and that if the bridegroom cannot defend them he is impoverished, and if he loses too many, he may even be sold into slavery along with his wife.

That on such a part of the African coast the women are exceeding skilled in the Ars Amatoria and that the women of the hinterland are extremely ignorant, and that therefore the inland women are sent down to the coast loaded with ornaments which the coast women immediately appropriate; but in return they instruct their land-lubbery sisters in all rites of the Cytherean goddess. And that the ignorant arrivals are called " Bahoh " (or something of that sort), but when they are ready to be sent back to their tribes they are called " Baheeah."

Also he was so accustomed to observe the dominant line in objects that after he had spent, what could not have been more than a few days studying the subject at the museum, he could understand the primitive Chinese ideographs (not the later more sophisticated forms), and he was very much disgusted with the lexicographers who " hadn't sense enough to see that *that* was a horse," or a cow or a tree or whatever it might be, " what the . . . else could it be! The . . . fools! "

And the talk was always staccato, partly from his nature, partly from the foreignness of his accent and the habit of pronouncing each syllable and of pronouncing his vowels like those in the last theory of Latin pronunciation. His spelling was impeccable.

The savant Gaudier was saved from the usual pedantry of the learned. It may have been a grace of youth, or of truculence.

Gaudier quoting the most learned treatise was indissolubly one with Gaudier, having had his hair cut or trimmed *vi et armis* by his sister, proclaiming himself audibly as " *discipulo di Cristo*" to a bus-full of scandalized Londoners, and carrying a few stone chisels in his pocket because he and Brodzky had been ridiculed and assaulted in some alley or at some slum crossing, and because he intended to go out of his way in order to pass there again.

At any rate, he was the best fun in the world, whether he was inveighing against the softness of modern customs, or telling tales of his life. Thus: when he was in Munich he was part of a Rembrandt factory. He used to go into the ghetto and draw types: the sweep, the vigour, the faces. Then a Swiss used to take the drawings up to the pinakoteka and carefully daub them *a la Rembrandt,* studying the mannerisms, all the ways of lighting the hands, etc., etc. And then a German took them and put on the tone of time, tea-leaves, etc., and then they were sold to a Jew. (O my country! Wherein I have seen galleries of " old masters.") Thus they made new Rembrandts, not doubtful copies or " originals of which the copies are at the Hermitage."

And why he left Paris, as follows :—

An artist had a mistress, and a sub-chief of police or some such person desired her, and either took her or tried to, and the artist assaulted the police and got three years, and in that time the sub-chief was successful. And when the artist came out he accumulated pistols and cartridges and did in more than a score of police (I forget the exact figure), and the Quartier Latin rose in riot and broke into the gaol on the morning of the execution and tore down the scaffold, and still the artist was guillotined and many students arrested, including H. Gaudier, who slipped under some one's arm and escaped.

He accepted himself as " a sort of modern Cellini." He did not *claim* it, but when it was put to him one day, he accepted it mildly, quite simply, after mature deliberation.

He was certainly the best company in the world, and some of my best days, the happiest and the most interesting, were spent in his uncomfortable mud-floored studio when he was doing my bust.

I had been out of town during the winter of 1913-14 doing

some work for Mr. Yeats. The bust was begun, I think after my return, and after the winter had loosened its grip.

Normally he could not afford marble, at least, not large pieces. As we passed the cemetery which lies by the bus-route to Putney he would damn that " waste of good stone."

He had intended doing the bust in plaster, a most detestable medium, to which I had naturally objected. I therefore purchased the stone beforehand, not having any idea of the amount of hard work I was letting him in for. There were two solid months of sheer cutting, or perhaps that counts spare days for reforging the worn-out chisels.

At any rate, there was I on a shilling wooden chair in a not over-heated studio with the railroad trains rushing overhead, and there was the half-ton block of marble on its stand, and bobbing about it was this head " out of the renaissance."

I have now and again had the lark of escaping the present, and this was one of those expeditions. It was not that he was like any particular renaissance picture. I have seen men made up to the very image of Del Sarto or of some other historic person, but here was the veritable spirit of awakening. He was, of course, indescribably like some one whom one had met in the pages of Castiglione or Valla, or perhaps in a painting forgotten.

And then sculpture was so unexpected in one's " vie littéraire." I had always known musicians and painters, but sculpture and the tone of past erudition . . . set me thinking of renaissance life, of Leonardo, of the Gonzaga, or Valla's praise of Nicholas V.

I knew that if I had lived in the Quattrocento I should have had no finer moment, and no better craftsman to fill it. And it is not a common thing to know that one is drinking the cream of the ages.

I do not think that there was much incident. It was this almost articulate feeling. He made first a number of drawings. One day when he was alone in the studio he attempted to shift the great block. It slipped, caught his hand under it, and he thought his sculpting days were over. He was imprisoned for several hours until he managed to attract the attention of some one working beyond the partition.

He slept one day in the studio, and woke up to find himself inundated with rain and lying in several inches of water.

The other member of the company was a kitten. I think it had been Spencer Gore's kitten. Gaudier modelled from it. He fed it with bits of meat suspended several feet in the air at the tip of a string . . . to teach it to jump. The young cat seemed to enjoy it and was visibly devoted to Gaudier.

He had made one tiny clay model of it on a shelf and trying to look at something beneath the shelf. It was the parody of all religion, a kneeling posture, a derision of all self-humiliating religiosity. It made a fair companion for an angel with enormous breasts, in alabaster with its robe painted scarlet and with the face of an ignominious Dante. He also parodied himself and his sister in wax, which parodies she threw either at him or at the stove.

An infant Hercules in grey stone had been broken in moving to this studio. The head rolled about the floor, a round object about half the size of a fist, it was one of the kitten's playthings. There was the large bas-relief of the wrestlers, some old work in one corner, the small forge, a representational bust, clay, in the manner of Rodin which he had, thank Heaven, discarded. He could tie knots in Rodin's tail when he liked, and he had got through with it.

The bust of me was most striking, perhaps, two weeks before it was finished. I do not mean to say that it was better, it was perhaps a *kinesis,* whereas it is now a *stasis;* but before the back was cut out, and before the middle lock was cut down, there was in the marble a titanic energy, it was like a great stubby catapult, the two masses bent for a blow. I do not mean that he was wrong to go on with it. Great art is perhaps a stasis. The unfinished stone caught the eye. Maybe it would have wearied it.

He himself, I think, preferred a small sketch made later, to the actual statue, but in sculpture there is no turning back.

There is in the final condition of the stone a great calm. Various of our artists have thought it one of Brzeska's best works. And I was interested to see how much it impressed Miscio Itow who comes to it with Eastern training.

A kindly journalist " hopes " that it does not look like me. It does not. It was not intended to. It is infinitely more hieratic. It has infinitely more of strength and dignity than my face will ever possess.

" You understand it will not look like you, it *will* . . . *not* . . *look* . . . like you. It will be the expression of certain emotions which I get from your character."

Oh well, *mon pauvre caractère,* the good Gaudier has stiffened it up quite a lot, and added so much of wisdom, so much resolution. I should have had the firmness of Hotep-hotep, the strength of the gods of Egypt. I should have read all things in the future. I should have been a law-giver like Numa. And we joked of the time when I should sell it to the " Metropolitan " for $5000, and when we should both live at ease for a year . . . some two or three decades hence.

My memory of the order of events from then on is rather confused. The bust was exhibited at the Whitechapel show because no other exhibit pays cartage on the works shown. He had also a faun in relief, another faun and a cat, I think, at Whitechapel that year.

The Holland Park show has been sufficiently mentioned. Winter wore into summer. There were Saturday afternoons at the Rebel Art Centre, that " social seat," so wonderfully misdescribed in " Il Piccolo della Sera " of Trieste that I think the reader will permit the quotation entire.

I VORTICISTI
SORPASSANO IN AUDACIA I FUTURISTI.
Versi da una a trecento sillabe!

I futuristi sono stati oltrepassati, artisticamente ed intellectualmente, da una nuova tendenza manifestatasi fra alcuni buoni temponi letterari ed artistici inglesi, che hanno inventata una nuova scuola. . quella dei " Vorticisti."

Non é la vita un vortice? Si dice di si, e ciò ammesso è naturale che anche l'arte e la letteratura diventino vortici avvolgenti nelle loro spire tutta la produzione intellettuale umana.

Nessuna legge, nessuna misura, nessuna impronta speciale, è necessaria per essere un pittore o scultore vorticista. La più grande, la più assoluta libertà è accordata ai seguaci della nuova teoria. Facciano essi quel che vogliono e come vogliono, purchè producano qualche cosa che non sia mai apparsa prima d'ora. In fatto di letteratura la libertà è anche più grande che non in fatto di pittura o di scultura, poichè i vorticisti, da buoni inglesi, tendono alla soppressione completa della grammatica e della sintassi; in poesia non conoscono metro, ai segni ortografici sostituiscono delle figurazioni, di modo che le pagina di un libro vorticista rassomiglia ad uno di quei " rebus " nei quali le parole si alternano colle figurine che bisogna interpretare. Come tutte le stranezze anche la tendenza vorticista trova i suoi entusiasti

in Inghilterra e questo entusiasmo si traduce in quattrini sonanti. Infatti per quanto l' idea del vorticismo sia stata resa publica a Londra da poche settimane i primi aderenti si sono già costituiti in associazione, hanno trovata una sede sociale che stanno adornando di insuperabili decorazioni di stile vorticista, si preparano a stampare un giornale per sostenere colla discus—sione le loro idee e fra non molto apriranno pure una scuola d'arte e di propaganda! Il capo riconosciuto della nuova scuol-a è il pittore Wyndham Lewis, un londinese di puro sangue, il quale ottenne numerosi premi alla scuola d'arte Slade ed ha avuto qualche buon successo anche nei circoli ortodossi della reale Accademia e dell' Istituto dei pittori inglesi. Egli ha per suo luogotenente il poeta americano Ezra Pound i cui versi vanno dal monosillabo alle trecento sillabe. Un altro dei più ferventi vorticisti è il decoratore Lorenzo Atkinson che ha pre-parati disegni per le cortine e le tende della sede dell'Associa-zione. Disegni nei quali è impossibile ritrovare la più piccola traccia di regolarità di simmetria, di tonalità, di colorito, o di ogni altra ordinaria pratica antidiluviana!

If the gentle reader does not understand Italian he had better let it alone, for no other tongue will give the true flavour. James Joyce sent me the clipping, but how all this nonsense ever got to Trieste remains a mystery to this day. It was, however, one of our jokes for the season.

A few of us lectured at the " social seat," the *sede sociale.* Gaudier distinguished himself by interrupting a futurist meeting and insisted on having the " c" in vorticist pronounced soft (*sic* ç), by their speakers. The *New Age* gave a pleasing and fantas-tical account of the affair.

The appearance of *Blast* was celebratèd in due state at " Dieudonné," on July 7th. Or rather the tickets were issued for July 7th, and the ceremony performed on July 15th, such being the usual proceeding of " il capo riconosciuto."

The feast was a great success, every one talked a great deal. It is this dinner to which Mr. Hueffer alludes in his description of Gaudier. Gaudier himself spent a good part of the meal in speculating upon the relation of planes nude of one of our guests, though this was kept to his own particular corner.

(It forms a pleasing parallel to Tagore's last function in Eng-

land, where he employed himself singing the most ribald of Calcutta street-songs as the only possible escape from the idiotic sanctimoniousness of his theo-floundering followers. I must say, if only in parenthesis, that wherever I have met either intelligent men or good artists they have been free of pomposity, free of an unseemly decorum, free of that gravity which Sterne recalls as " a mysterious carriage of the body to conceal the defects of the mind," free of that cult of the innocuous which so marked the elderly and senescent literary circles of England and all the published circles of America before the present war. It is only the dull and the cowardly who try to impede the swiftness and legerity of the mind.)

" Il avait l'âme pure," our Gaudier, and I think this clarity is wholly incompatible with flatness. We may even imagine a certain *gamin* amusement having played about the lips of a still earlier artist when he chivvied the usurers out of that historic monument in Jerusalem.

In less than three weeks after the dinner the gigantic stupidity of this war was upon us, the accumulated asininity of that race which " N'a jamais pu qu'organiser sa barbarie," and the vanity of an epileptic had tumbled us into the whirlpool.

Gaudier had evaded his military service in France. He went almost at once to the Embassy, where they told him he might return without penalty. He left Charing Cross and all the art-feuds of young London were at truce for half an hour. Two days later he was back again, seated grinning upon my divan.

He had gone to Boulogne and presented himself to a square-set captain with his grey hair *en brose,* who said—

" What, insubi ! ! Ten years in Africa !"

To which Gaudier : " But I came back of my own free will, to fight."

The captain : " It's a very good thing you did, otherwise you'd have got twenty years in Africa. What ! Non ! la patrie n'est pas en danger ! ! 'MENE MOI C'T HOMME LA ! ! !'"

After which they put Gaudier into what he called a " swank automobile " with a lieutenant and four men with (I think he said) " fixed bayonettes." They took him off to a guard-house in Calais. He enjoyed the ride, the lieutenant was amiable and keen for the last news from London.

The guard-house was an improvised one. He was put into a large room with one minute, high window, was told that there was a sentry outside and that he would be shot dead if he attempted to escape.

"That was eight o'clock," he said, "at twelve——"

I said: "You had a happy four hours."

He said: "I sweat more than I ever did in my life."

At twelve he managed to reach the high window and looked out: there was no sentry at that side of the house. He did not try to see if there was one at the door. Being half the size of the expected prisoner he managed to get through the window and put back for Boulogne. He arrived there at four a.m., lay in the fields until five. Approached the gate-keeper by the English boat with a different passport from the one he had used the preceding evening, swore that he was English and had an Italian father, and that he had come over the night before to fetch some luggage. He was pleased to convince the gate-keeper, that he, the gate-keeper, remembered his, Gaudier's, having come for the luggage. Aboard the English boat he had the pleasure of being escorted all the way across the Channel by a French torpedo-craft.

He was back here for about three weeks, undertook to make two huge garden vases for Lady Hamilton, got very much bored with it, finding the stone much harder than he had expected. He did, I think, two other pieces during this time. The bombardment of Rheims was too much for him, his disgust with the boches was too great to let him stay "idle." He got some better guarantee of safe-conduct from his Embassy and went back to his death, though his own genius was worth more than dead buildings.

VII

THEN came postcards, one of the fort at Le Havre, " I am drill-ing, etc."; a photo-card of the squad : " I am off to the front," etc.

The first letter.

Sept. 24th.

MON CHER EZRA,

Je suis dans un village et j'y monte la garde une heure le jour, une heure la nuit, j'écris à l'accompagnement des grosses pièces d'artillerie qui envoient aux boches de la confiture, je suis sur les lignes depuis 5 ou 6 jours, nous sommes allés tout près des tranchées, nous avons reçus quelques obus sans grand mal, puis nous avons un detachement au village d'ou j'écris, j'ai été choisi comme éclaireur, alors à la première marche en avant je ferai partie des patrouilles, je me porte bien et éspère voir les alboches de beacoup plus près. Mes meilleurs souhaits,

HENRI GAUDIER.

Il n'y a pas de timbres aux villages, j'éspère que tu n'auras rien a payer sur la lettre.

Lundi, Sept. 28th, 1914.

DEAR EZRA,

Je reviens d'un enfer d'ou peu échappent, avant hier dans la nuit ma compagnie a opéré une attaque contre la route ou des prussiens étaient installés, nous y sommes allés à la bayonette, puis nous sommes fusillés d'abord à 5o m. ensuite du bord talus de la route à l'autre ou les alboches se tenaient, j'en ai vu deux montrer la tête et je les ai envoyé au paradis, mais partis 12 de mon escouade nous nous retrouvons aujour d'hui 5 seulement. Je t'écris du fond d'une tranchée que nous avons creusée hier pour se proteger des obus qui nous arrivent sur la tête regulière-ment toutes les cinq minutes, je suis ici depuis une semaine et nous couchons en plein air, les nuits sont humides et froides et nous en souffrons beaucoup plus que du feu de l'ennemi nous

avons du repos aujourd'hui et ça fait bien plaisir, donne mes civilités à Mrs. Shakespear, à Richard (Aldington) et sa femme et bien à vous deux.

<div align="right">HENRI GAUDIER.</div>

The next note is in English. October 11th. He is in trenches a foot deep in mud, expecting a march forward. He has not had " the opportunity to let a shot go," etc.

" I do not despair of ever reaching Dusseldorf and bringing back the finest Cézannes and Henri Rousseaux to be found up there. We are not very far from the German frontier as it is."

" If you send anything, send chocolate, etc."

<div align="right">October 24th, 1914.</div>

I am writing from a trench, I have spent four hours of the night on sentry duty before the lines, I have not had the luck of sighting an enemy patrol, tho' at a time I saw several men move, at sunrise I made out what it was : barbed wire nets stuck on stout posts. For the day we have to stay inside this beastly hole without even having the satisfaction of firing a shot. Perhaps to-night we shall have greater fun, anyway it is a happy life, there are hardships but sometimes we can steal away two or three with a sergeant and bring back wine, beer, etc. . . .

Sunday.

A fine sunshine and better mood than yesterday. I have even been thinking about writing a short essay on sculpture for the *Blast* Christmas No. Please let them reproduce in it a photo of your bust. I shall send the essay as soon as finished, but all depends upon the fighting. If we have a few quiet days you'll have it soon.*

<div align="right">November 7th.</div>

MY DEAR EZRA,

Yes I have survived and will continue to do so, I am absolutely sure. We are at rest to-day after a week's trench life. We have had rain, mud, sunshine, bullets, shells, shrapnels, sardines and fun. I am well weathered and covered . . . have more socks . . . etc. than I ever shall wear out within the next

*" Vortex " essay referred to appears on page 19.

<div align="center">56</div>

six months. Please keep the sweater, don't have it dyed, send it when the winter has set in really, etc.

The only things he wants are numbers of the *Egoist,* cigarettes, chocolate, poems. He promises the article before "next Monday."

"As I am ordered for a night patrol, it will be the 12th that I do. We are only four in the company for this work. We set out at sun-down and come back at dawn. This time we must go to explore an old bombarded mill within the German line where a maxim-gun section is in position. We shall have luck I have a good presentiment.

" I have not received any news since October 5th, etc. . . .

" I am writing this on the back of a book pinched from the ' Boches,' it is a cheap edition of ' Wallenstein," I am trying in vain to interest myself in its complicated nonsense. This is why I want some wholesome literature. Be sure that Hueffer does not lessen the German aggressions."*

November 9th.

Dear Ezra,

I have had the greatest fun this night of all my life. I started with two men under my command to reinforce wire entanglements at a few yards off the enemy. We were undisturbed for a long time, my fellows went on driving in poles and I was busy setting wires lying on my back when the silly moon shone out of the mist. The Germans caught sight of me and then pumpumpumpumpumpum their bullets cut four barbed wires just above my face and I was in a funny way indeed caught by the loose wire. I grasped my rifle at last and let them have the change, but it was a signal : my men lost their heads, one let his rifle fall into his wire coil, threw away the wooden mallet and jumped into the trench as a wild rabbit, the other in his wake, but this latter did not forget the gun. When they came in they said I was dead, and to avenge me my lieutenant ordered volley firing, the boches did the same, and I got between the two. At great risk, I came back to the trench, where my lieutenant was very astonished. When the row ceased and the

*An allusion to Ford Madox Hueffer's " When Blood is their Argument."

fog set in again I went back with my two chaps, found everything back and completed the wire snares. I got your letter and replied. I am beginning the essay now.

Yours ever.

December 1st.
(Post-card, of the ruins of Rheims, with a gargoyle of " le coq gaulois " left intact) containing thanks for cigarettes, sweater, etc., and the phrase, " I don't deserve so much, as the suffering is very restricted " . . .

" Nothing new, we killed a German a few days ago."

" It's amusing to know about the artist volunteers and still more about being appointed professor in a Colorado institution. Do send them my thanks, and say I'll go and take up the position after the war, etc."

The vortex essay finally arrived.

December 18th.
The poems depict our situation in a wonderful way.* We do not yet eat the young nor old fern shoots, but we cannot be over victualled where we stand. I have already told Wadsworth where I am at the present moment, and doubtless you see the swamps as well as I. Before Rheims we had dug hibernating trenches which we had accommodated with all possible care, and we only slept once in this seeming comfort to be ousted over here. I was spying a German through a shooting cranny and loading my rifle when the order came to pack up and get ready to start on a night march. We did not know the destination : some were sure we went to rest some 20 miles behind the lines, others said we were led to the assault of a position, and this seemed confirmed when they took away our blankets to lessen the weight of the knapsack. Anyway, no one foresaw the awful ground we had to defend. We must keep two bridges and naturally as usual ' until death.' We cannot come back to villages to sleep, and we have to dig holes in the ground which we fill with straw and build a roof over, but the soil is so nasty that we find water at two feet six inches depth; and even if we stop at a foot, which is hardly sufficient to afford cover, we wake up in the

* This refers to a couple of translations from the Chinese of Rihaku, and another by Bunno which I had wrongly ascribed to Kutsugen.

night through the water filtering up the straw. We have been busy these last nights bringing in lots of materials, stoves, grates, etc., to make decent abodes, and unhappily they will be done just in time for us to go, as we are relieved of the post within three weeks. The beastly regiment which was here before us remained three months, and as they were all dirty northern miners used to all kind of dampness they never did an effort to better the place up a bit. When we took the trenches after the march it was a sight worthy of Dante, there was at the bottom a foot deep of liquid mud in which we had to stand two days and two nights, rest we had in small holes nearly as muddy, add to this a position making a V point into the enemy who shell us from three sides, the close vicinity of 800 putrefying German corpses, and you are at the front in the marshes of the Aisne.

It has been dry these last three days and the 1st Battalion has cleansed up the place, I believe. Anyway, we are going back to-night, and we shall finish the work.

I got a sore throat in this damned place and lost my knife while falling down to avoid bullets from a stupid German sentry, whom I subsequently shot dead, but the stupid ass had no knife on him to replace mine, and the bad humour will last another week until I receive a new one from my people.

Anyway the three weeks here will pass away soon. I take the opportunity to wish you and your wife a Merry Xmas and a prosperous 1915.

<div style="text-align:right">

Ever yours,

H. Gaudier.

January 27th, 1915.

</div>

My dear Ezra,

I was writing you a post-card to Stone Cottage when your last turned up. We are at rest again in the same farmhouse for six days and we are glad of it. These last 12 days in the trenches were hard, it has been raining and every night we had to puddle ankle deep; in the daytime we had to empty ditches and dry our clothes. I have heard from Hulme when he was at Havre on the way to the trenches; it will change him a bit from the comfort he had at Frith Street. I had the luxury of only one patrol, we had to wait for a beastly night to do it as the Germans are too near us.

I started with a sergeant and it was so dark that walking side by side we had difficulty to see each other. We went all along their barbed wires, paid visits to all their sentry posts, which we found empty, and only got one shot fired at us when we got at the corner of a burnt farmstead within their line. The bullet whizzed past our heads and stuck itself in the ground splashing our faces with mud. We had just come from this little emotion when we crossed our own wires and came near our sentries. There was a youngster on duty and my sudden appearance surprised him so much that he let me have a bullet at five yards which missed the mark. The poor fellow got such a fright that he shivered for two days, but of course he had to enjoy a first rate licking with the butt end of a rifle from the angry corporal on the spot. Since we only had only a sham attack the night we were leaving for rest, attack in which my company was not engaged. All the time there have been violent artillery duels in which nobody got the better.

(. . . some data *re* repayment for a statue, request for reading matter, etc. . . .)

Do send me the series from the *New Age* so that I may see the eulogies. Hulme has told me in detail what Epstein had lately been doing, and from the description I should be glad to see the works, perhaps I will once. If I return am sure I shall not work like Condor.* But I believe I shall develop a style of my own which, like the Chinese, will embody both a grotesque and a non-grotesque side. Anyway, much will be changed after we have come through the blood bath of idealism. Wadsworth has told me in a letter that Dunoyer de Segonza† fell in Lorraine; he leaves a complete work. His end may have been a great fact.

X . . . has retired to the still quarter (Hampstead), he is near . . . up there, if I remember well, so that it approaches to a perfect gentle company. It is better for him, he won't be tormented by doubt.

* In my letter I had threatened him that in reaction from his present life in violence, he would react into Condor, the nineties, delicate shades and half, lights, hence this reference.

† This is an error, it was another Segonzac.

My squad behaved so well yesterday that I had the pleasure of bringing six of them into quod last night. During a pleasure march they left both rifles and sacks in a field and went to a pub and never came back in time, a corporal was left in charge of the weapons and the major saw it, so that to-day I am left with two cooks, a sick man, a red cross fellow and an innocent.

It is as bloody damp here as it was with you a week ago when you wrote, and I again indulged in the luxury of " mud baths," very good for rheumatisms, arthritis, lumbago and other evils. But nowadays I am a trench veteran. I have experienced all sorts of weather in these hellish places, so that I can stand a night under a heavy rain without sneezing the next day, and sleep beautifully a whole day on hard frozen ground without any ill result to the " abdomenalia." Nevertheless I am writing from a barn behind the lines, a good old sheepfold full of straw where one is warm, and needless to say I enjoy it and appreciate the happy position, especially as I have been able to find good cigars and wine in the village.

Let all the hordes of city clerks and kilted Highlanders come to reinforce us and take up the offensive when the weather is fine again. I dislike rotting away in a ditch like an old toad. Our army is forming behind us, we are being re-equipped with better fighting clothes, soft greys instead of bright blues and reds. We get American boots and socks, English gloves and scarves. We'll do fine work soon.

The other day at noon during bright sunshine when the officers were asleep I went out of the trench with a friend and we two attacked the enemy. We came within 60 yards of their trench, we had fits of reciprocal politeness via our rifle barrels, and came back amid a hail of bullets which did us no harm, as usual, but with a helmet and a rifle as prizes which a sentry afflicted with bellyache had left in his post of observation which we stormed. I have received the *New Age* where you write about me, also the one you have just sent.

14/3/1915.

I am at rest for three weeks in a village, that is, I am under-
going a course of study to be promoted officer when necessary
during our offensive.*

I am about to be made a sergeant. . . . The weather is now
magnificent and I am astonished to have been through such a
badly wet winter practically in the open air without getting any
the worse for it. I have been patrolling lately; we had lively
volleys in the early hours. I threw a bomb also in a very black
night into the German line: all great fun. It will be a little
harder when we have to pierce thro' their three lines of trenches
soon; but thereafter the pursuit will be quick and decisive, and
I shall get to Dusseldorf perhaps in a week after having waited
six long months in the damp.

As we are here six comrades and we can get wine and other
suitable liquids, could you send me a couple of pounds during
the 21 days we have to stay ?

20/3/1915.
(Some data about his statues, prices, etc.) There is a big
marble, a sleeping woman, which you have never seen . . .
etc. . . .

For the present I am quiet, still and happy, there's no more
trenches for three weeks, but an interesting course some miles
behind the lines. They are training us to become officers. I
wrote you a few days ago about it, but I addressed the letter to
Colemans Hatch . . . etc.

In the night we can go on top of the hills and see the fireworks
all along the line from Soissons to Rheims. It is so calm to-day
and the fellows are writing and reading so quietly that it's diffi-
cult to imagine one's self at war. But I have some presentiment
it is the great calm preceding violent storms, for which we are
now well prepared.

. . . We are so much out of the habit with heated stoves that
we can't stay inside the peasants' cottages. Now we shan't suffer,
the frosts and the heavy rains are gone.

I'd be glad to see a few Chinese poems.

* He had been made corporal some weeks or a month or so before this,
but there was no word of it in his letters to me; nothing save the change
in the return address which now read, Henri Gaudier, caporal, 4e section,
7 cie, 129 infanterie, etc.

Many thanks for the poems, I am glad of having the Rihakus. There is nothing exciting happening.

Post-card.

Two post-cards, requesting puttees, etc. " I am in the best of spirits, trenches are a pleasure now, no more mud."

" The Germans don't give us much trouble, I haven't seen any for weeks."

Post-card.

(Details) . . .

There is nothing very special here. Spring in all its beauty, nightingales, lily-of-the-valley in the trenches, and the Germans have been routed. They dared attack our entrenchment. We killed 1,250, but the horrid side is the stench now. We had a handful of prisoners. We are far away from the lines resting. I shall write soon to Wadsworth. Tell me of anything that may happen in London.

The following letter is dated 3/5/1915, but my recollection is that I received it after the one dated May 25th. The postmark is faint but seems to indicate " 6," *i.e.* June. It is the only letter in which he shows any premonition of death.

I have further verification that it was sent in June, not May.

DEAR EZRA,

I have written to Mrs. Shakespear in what a nice place I was. It becomes worse and worse. It is the 10th day we are on the first line, and the 10th day we are getting shells on the cocoanut without truce. Right and left they lead Rosalie to the dance, but we have the ungrateful task to keep to the last under a hellish fire.

Perhaps you ignore what is Rosalie? It's our bayonet, we call it so because we draw it red from fat Saxon bellies. We shall be going to rest sometime soon, and then when we do come back it will be for an attack. It is a gruesome place all strewn with dead, and there's not a day without half a dozen fellows in the company crossing the Styx. We are betting on our mutual

chances. Hope all this nasty nightmare will soon come to an end.

What are you writing? Is there anything important or even interesting going on in the world.? I mean the " artistic London." I read all the " poetries " in one of the *Egoists* Mrs. Shakespear sent along. Away from this and some stories of Guy de Maupassant and E. Rod, I have read nothing, a desert in the head a very inviting place for a boche bullet or a shell, but still it had better not chose this place, and will be received in the calf for instance.

You ask me if I wanted some cash not long ago. No, not here, but as you may imagine things are pretty hard and I should be thankful if you could send what remains to my sister . . .

Have you succeeded with Quinn?

(The Germans are restless, machine-gun crackling ahead, so I must end this in haste.)

<div style="text-align:right">Yours ever,
HENRI GAUDIER.</div>

His premonition of a head wound is curious, for this letter was written I believe only two days before his death. His sister tells me that years ago in Paris, when the war was undreamed of, he insisted that he would die in the war.

The question about the sales to John Quinn were answered later in Quinn's letter.

" Now here is the distressing thing to me personally. I got yours of April 18th on May 10th. It was mostly about Brzeska's work. I intended to write and send you £20 or £30, and say ' send this to him and say it can go on account of whatever you select for me.' But a phrase of yours stuck in my mind, that when he came back from the trenches he would be hard up. Poor brave fellow. There is only the memory now of a brave gifted man. What I can do I will do."

I quote this because Mr. Quinn is one of the few collectors who realize that if a man buys the work of artists who need money to go on with, he in some measure shares in the creation. He gives the man leisure for work. Whereas the dealers in dead men's work are uncreative, they are merchants and shifters. And I am on this account glad that Gaudier's work will be preserved

in the South Kensington, possibly the Luxembourg, and certainly in the great modern collection of a man who would have been his good friend had he lived; and that at least some representative number of Gaudier's statues will be in one place together, rather than being scattered among dealers who would merely wait for the price to advance.

VII

LETTERS TO MRS. SHAKESPEAR

January 9th, 1915.

.

We left the trenches a few days ago and came to rest some 15 miles behind the lines and there has been so much washing, cleaning and brushing to do that the correspondence suffered . . . Our life came very near that of stone or rather hole monkeys. We had a stretch of 25 days without sleeping in a dry place and without a single chance of washing . . .

We went four times in three days five strong with a reserve of ten behind in case of a perilous enterprise. We drew the Germans in a wood every night, they came at first 25 then 40 and each time we remained some 30 yards away from them in the grass and shot away for three hours. They got so much annoyed one evening that they sent us 38 shells; but of course being only five we scouted away and let them burst harmlessly. We licked a lot of Germans. . . .

I have lately been promoted corporal so that I am having a much better time of it now, there is no more sentry duty . . . nor carrying timber and setting wire entanglements. I supervise instead, which is the better part.

Feb. 4. . . . " war, which is beginning to try my patience," details as in other letters and respects to " Max," who is to be " sculpted " on Gaudier's return.

BEFORE CRAONNE

March 1st.

Your cigarettes are delightful in these places, especially where one cannot dream much, shells being a very disturbing agent. I have some fellows in my squad who cannot at all bear them, and do they even burst 200 or 300 yards away or simply pass overhead, they disappear under ground like as many rabbits and with much more celerity. Notwithstanding the eternal bombard-

ment I managed to have gay and pleasant visions this morning all entangled in the blue smoke.* Indeed I have been living happily lately. We had a stay of some eight days in a trench only 20 to 50 yards away from the Germans, and I used the opportunity to pour upon the Kaiser's legions all the swear words I had learnt in the Vaterland. They hauled up a board on their trench with the inscription in French :

<div align="center">

94,000 Russians taken,

71 cannon,

1,000 maxims.

</div>

I shot it down and I put up one made out of a bullet-proof steel sheet. I had written in German :

<div align="center">

How do you like

the war bread!

</div>

They shot clear through it and it fell on the back of a sergeant, who in his misfortune pulled down the regiment's chaplain who was watching. The sergeant-major ran away, losing all his papers and pencils, and all the trench burst out laughing. Then we let off a volley over the trench.

Another day I talked to the Saxons from 7 to 10 in the morning, exhorting them to come and constitute themselves prisoners; but they wouldn't. Then under the pretext of exchanging newspapers I went out and met a German in order to take him, but as he wanted the same thing we went half way, handed each other the news and came back. Later on I showed the artillery where their small outpost was, and at 3 o'clock they all went up.

<div align="center">

BOURGOGNE (MARNE)

</div>

<div align="right">

19/3/1915.

</div>

(Details of the officers' training corps.)

I don't believe for once to go back to the trenches for long. We shall pursue the boches, it will be hot but rather agreeable, same temperament as " Altaforte," and we shall have fellows able to take command of the section in case the officers are hit.

. . . Tell Max (the cat who was to be sculpted) that I shall do him no harm. We have a wolf-dog as a mascot. He runs

* As I have indicated elsewhere he was definitely a visionary and " saw " both in waking vision and in sleep.

after hares the whole day; his name is Loulou; he used to come out patrolling sometimes but gave too much attention to partridges.

April 11th.

The war won't be over for another year. . . . You can tell me anything you like about the rumours you talk of, there's no censure on letters. . . . Thank you for the news about the " Singer." I am getting convinced slowly that it is not much use going farther in the research of planes, forms, etc. If I ever come back I shall do more " Mlles. G. . . ." in marble. For the present I should like to see some love poems : seven months' campaign gives desires which seem very commonplace in usual times, and sensualists have for once my whole sympathy.*

Please give my compliments to . . . and . . . and may it be an artist and a warrior that sees the light, as they are the only people who can be admired now.

E . . . has sent me the Chinese poems. I like them very much. I keep the book in my pocket, indeed I use them to put courage in my fellows. I speak now of the " Bowmen " and the " North Gate " which are so appropriate to our case.†

I shall never be a colonel but I expect to be promoted lieutenant very soon, and that will be the end of the *carrirè;* sixty men are quite enough for my strength. I have now about 30 to command and it is much more amusing than being commanded by a grocer or a pawnbroker. My lieutenant is a baron of the old stock, a very brave man, intelligent and a fine education, so that I am happy.

I have seen Siamese cats, they are fine animals to sculpt, I quite see you stroking the 28. When I was a boy there was in the neighbourhood an old lady who had about 50 cats, we used to call her " la mère aux chats," and played all sorts of nasty tricks to her protégés, but I should not to you. I am going back to the trenches in 3 days now.

Ever yours,
H. GAUDIER.

* " Mlle. G. . . ." is the nickname of a naturalistic torse, plumper and not so fine as the one reproduced. He had repeatedly stigmatised it as insincere. However, this passage is all that I can find about the " renunciation " so vaunted by our enemies.

† One poem by Bunno, of at least the fourth century B.C., the other by Rihaku written in the eighth century A.D.

DEAR MRS. SHAKESPEAR,

Our woods are magnificent. I am just now quartered in trenches in the middle of them, they are covered with lily of the valley, it grows and flowers on the trench itself. In the night we have many nightingales to keep us company. They sing very finely and the loud noise of the usual attacks and counter-attacks does not disturb them in the least. It is very warm and nice out of doors, one does not mind sleeping out on the ground now.

I have heard W. Rummel already, at your house once, and Chopin and Beethoven are my preferred musicians. Needless to say that here we can have nothing of the kind, we have the finest futurist music Marinetti can dream of, big guns, small guns, bomb-throwers' reports, with a great difference between the German and the French, the different kinds of whistling from the shells, their explosion, the echo in the woods of the rifle fires, some short, discreet, others long, rolling, etc.; but it is all stupid vulgarity, and I prefer the fresh wind in the leaves with a few songs from the birds.

In case I should be wounded I would let you know from the hospital some time afterwards. If I was killed of course there could be no direct news, but then you could write to my captain :

Captaine B. Menager,
commandant la 7 eme. Cie.
129 regt. infanterie,

but only after a very long silence on my part.

Really the English fleet can't be so serious as we imagined : these U-boats seem to be allowed to tramp the seas at their own will. That the English are not careful enough on sea and land is the feeling among us. I knew Sir Hugh Lane. We got the news of the *Lusitania* the very day it happened, and we were in the trenches then; we also know day by day what happens on the front. I am very far off the English and Indian troops, so can never see them. Compliments to Max.

DEAR MRS. SHAKESPEAR,

It was a pleasure to have news : we had our correspondence very late, 8 to 10 days without letters, and the place where

I get it is anything but delightful for a stay in the country: the foremost trench element near Neuville, St. Vaast! a continual bombardment, and endless inferno. I have been buried twice in the trench, have had a shell bursting in the middle of a dozen hand grenades, which miraculously did not explode, and men nastily wounded whom I must give the first aid. We are betting on our chances, whose turn it is next.* The boches are restless, but we pay them well, they dared attack the day before yesterday. It has been a lurid death dance. Imagine a dull dawn, two lines of trenches and in between explosion upon explosion with clouds of black and yellow smoke, a ceaseless crackling noise from the rifles, a few legs and heads flying, and *me* standing up among all this like to Mephisto—commanding: " Feu par salve à 250 mètres—joue—feu! " then throwing a bomb, and again a volley—until the Germans had enough of it. We give them nice gas to breathe when the wind is for us. I have magnificent little bombs, they are as big as an ostrich egg, they smell of ripe apples, but when they burst your eyes weep until you can't see, you are suffocated, and if the boche wants to save his skin he has to scoot. Then a good little bullet puts an end to his misery. This is not war, but a murderer hunt, and we have to bring these rascals out of their holes, we do it and kill them remorselessly when they do not surrender.

To-day is magnificent, a fresh wind, clear sun and larks singing cheerfully. The shells do not disturb the songsters. In the Champagne woods the nightingales took no notice of the fight either. They solemnly proclaim man's foolery and sacrilege of nature. I respect their disdain. Many thanks for the explanation about the fleet, tell me what comes out of the enquiry if you please.

If my letters are worth your using them I should be glad and give my best wishes to the work.† (I become rather interrupted because of the enemy. I tell you they'll end by wounding me.) . . . All I can give you from here is a buttercup, the only flower that grows on the trench (we are in meadows) and not a very nice flower, but it is a souvenir from the hard fights at the

* This also dates the letter to me, which I believe to be of June 3rd; Mrs. Shakespear remembers that I received it after she received this one.
† A novel in question.

Neuville. (Again broken off, there's a machine gun rattling away in the village. I must look above the trench to see if they are not coming.)

It has stopped . . . false alarm.

No signature, but a pencil sketch of " part of the place from my trench."

IX

LETTERS TO EDWARD WADSWORTH
" Wadsworth est très gentil pour moi."

November 18th, 1914.

MY DEAR WADSWORTH,

I have your letter with the woodcuts; it's a great relief to touch civilization in its tender moods now and then. I have been unmobilized for a week by a slight wound in the leg received on Nov. 8, during the night while strengthening a wire entanglement. To-day I am in a deserted villa. I slept in a good bed for the 2nd time in 2 months and I was quietly reading an article upon the primitives of Germany in the *Revue des 2 Mondes* when I got the woodcuts of a primitive, shall I say, but of another tinge. I knew " Flushing," it was hanging on Ezra's wall when I departed, the others are quite new to me. I have some preference for " Rotterdam." I do not know why, as the same qualities persist through them all, at the same degree. When you send me some more, as I am greedy to see much vorticism just now, print them on the thin. The reason is this, I have room for them in my knapsack and the less weighty the individuals are, the more I shall be able to stuff in, and I must have room for what awaits me at Düsseldorf.

I posted yesterday the unhappy essay I had promised, it is much more a letter than anything else, but you may imagine how difficult it is to concentrate your mind upon any subject when you are obsessed by fighting. Now would be the time to read over and over again Ezra's " Altaforte."

In the place we are in to-day there is nothing to see. It is all false French luxury, damnable imitation Louis XV-XVI. There's one small statue of a seated Christ, Polish work I believe, very primitive with a great emotion, it is carved in a log of oak, otherwise nothing at all except old *Revues des 2 Mondes.* Your letter came as a godsend anyway.

I thank you heartily for the packets, but I must scold you too. . . . sends, you do, other friends do the same, so that I am abso-

lutely spoilt as a fighting unit (which will make you laugh), anyway the moral is much worse. I am always in good spirits, be it in the mud of the trench or in the warmth of the 'biwack.

I shall come back stronger, I think; it is a good tonic to suffer some discomforts after the very soft life we lead in the towns. I have no new feats to relate, of course, but I hope to have something more to say next week.

To come back to the parcels, they will be welcome but don't send too many. Give my best regards to your wife. Ever yours,

H. GAUDIER.

Of course you won't forget to give news to Ezra, Richard, Cournos, all Kensington.

Note.—The " very soft life of the towns " included " Cher Henri's " going to sleep in his studio under the railroad arch and awakening to find himself lying in three inches of water, long tramps with his sculpture slung on his back, etc., etc.

The " Düsseldorf " joke might almost need a separate chapter. He sat where I am now sitting and took notes on what should be fetched out of Germany. The Pinakoteka was discussed, but he settled on the " Picasso's " at Düsseldorf as the *spoila opima,* and threatened to bring them away in his boots.

December 16th.

To Wadsworth, compliments on the birth of a daughter. Gaudier is " 30 miles up northward," it is " the third circle of Dante's inferno." 800 Germans dead on the ground, unburied and unburiable. " Showers of shells daily and it is a wonder nobody gets hurt."

January 18th.

Many thanks for the news. . . . I am glad to see you can work, and like especially the woodcut you sent. Away here, of course, one gets fits of intellectuality now and then, but usually it's a state of soldiery with no greater desires than those of drink, good eating and a dry bundle of straw.

. . . He is on rest after 25 days of trenches, devils of dampness, etc. He repeats the incident of " drawing the Germans in a wood," the five of them, and the sound of " Hoch, hoch,

73

vorwarts." " We got away as usual and did them a lot of harm, too."

26/1/15.
Before Perthes, the " dam'd river is overflowing." My chaps are cleaning reserve cartridges. . . . Military data, etc.

Feb. 18th. Letter containing the two drawings done before Craonne.

X

1912-14

THE FRIENDSHIP WITH BRODZKY*

I FIND that Horace Brodzky has kept two of Gaudier's letters; one, dated Jan. 6th, 1912, " please if you could call . . . supper together, and conversation."

He had seen a wood-cut by Brodzky and wrote to make his acquaintance. The second letter, addressed to " Brodzky del Sole," Nov. 13th, 1914, contains remarks about trench fighting which overlap with other letters here printed. He says also, " Cap got reversed by a bullet," and " Thanks for news about Currie, I knew nothing." He goes on to say that suicide is foolish, and that in the thick of fighting with so many dead about, the suicide was not " impressive."

According to Brodzky, Gaudier had spent the year 1912-13 as a clerk of some sort, doing city correspondence, translation, etc. He had worked after hours studying " everything," Egyptology, China, etc. Also he had made several large posters for advertising, all of which were refused.

He had done illustrations for Frank Harris' "London Society." Some of these drawings are quite good. The caricaturing is excellent. There were also various experiments, a few etchings, a single dry-point which was scribbled on the back of a scratched plate; a pastel portrait of Brodzky, and finally a high-relief of two women in plaster (about a foot square). The dry-point is dated 1913, the pastel 1912.

A head of Brodzky shows the effect of a theory that painting and drawing are first of all calligraphy. It is a belief Chinese in origin, or else deduced from Chinese work by some occidental theorist. It shows in the drawing of Brodzky's moustache, also on the delicate drawing of a faun now in his possession.

Brzeska's later drawings, so far as I personally know, are done almost invariably without any trace of this belief. They were

* Vide also page 30.

for a long time done in very thin even line, almost as if they were done with a stylographic pen.

In many of them he had undoubtedly no further intention than that of testing a contour for sculpture; certainly this was the case in the numerous sketches he made for my bust, and must have held true for many of the nudes and animals which comprise the bulk of the drawings.

As for the legend of Gaudier's life, Brodzky had gathered the following impressions and statements :—

Gaudier's ancestors had been masons and stone carvers for generations and had worked on the cathedral of Chartres. Brodzky himself had discovered an almost exact portrait of Gaudier, carved on some French cathedral façade. This gave piquancy to an, of course, unverifiable fancy.

Gaudier's wanderings afoot about Europe had taken place between his ninth and fourteenth year. This corresponds vaguely with something Gaudier has told me himself. " Gaudier said he had worked mending roads in Germany during these tours." Possibly he may have, for a day or two or to provide a stray night's lodging.

Gaudier took part in the Hervé riots in Paris. Gaudier had been through Wales. He had made a particular pilgrimage to a certain tree, that blooms on a set day in the year because of the warmth of the Gulf-stream. (This might be out of a Japanese " Noh " play, but it isn't.)

Frank Harris told Brodzky the following tale of Gaudier's first carving in stone. Gaudier, ætatis suae XVIII or thereabouts, met Epstein, who said, mustering the thunders of god and the scowlings of Assyrian sculpture into his tone and eyebrows, " UMMHH ! Do . . . you cut . . . direct . . . in stone? "

" Most certainly ! " said Gaudier, who had never yet done anything of the sort.

" That's right," said Epstein; " I will come around to your place on Sunday."

So Gaudier at once went out, got three small stone blocks, and by working more or less night and day had something ready by Sunday.

This may very well have happened. There is a parallel tale of Michael Agnolo chiselling an old faun in the Medici's garden.

Cosimo said, " An old faun wouldn't have all his teeth good as new."

Two teeth were nicked out on the instant. It is perhaps one of the readiest marks of genius that it can accept the *right* idea instantly and without cavil, that it does not reject an idea merely because it is not its own, or because it runs counter to a personal error or thoughtlessness.

Gaudier acted for a time as art-adviser to Frank Harris and did a representative bust of him. He also did several other portrait busts in plaster. These representational busts do not particularly interest me, but they do serve to show Gaudier's ability, as, for the matter of that, do some of the comic drawings, notably where having done some drawings on brown paper with blue ink, which renders them unsuitable for reproduction because the camera takes blue as white, he copied them in black and white with amazing exactness. There is nothing in this, but it is the sort of detail which impresses the lay mind and shows it the difference between chance rightness and the mastery of a medium.

He was a master draughtsman, and sculpture is consummate draughtsmanship, it is an infinite number of contours in one work, and on that rests much of its durability of interest. The picture we have all at once and we must walk round the statue.

Friendship with Wolmark*

Alfred Wolmark knew Gaudier before I did. Gaudier was in and out of his studio a good deal. Wolmark has done two portraits of him. Mr. Wolmark has been good enough to meet me at the Café Royal and communicate his impressions and some opinions on Gaudier.

He said that Gaudier " never came into the house without making drawings, of the people there, of models; caricatures, anything . . . and no matter what he drew the drawing was always a living object."

It was on his way to Wolmark's that Gaudier was set upon by roughs, or rather they jeered at him and pulled his cape, so he assaulted three of them, was very much mauled, lost a few

* Vide also page 30.

teeth, and inflicted, we believe, considerable damage on his opponents. He arrived at Wolmark's silent, almost unrecognizable, incapable of speech or mastication.

Wolmark says that Gaudier had no nerves, that he could draw anywhere, at any time. He pictures him going off to the Zoo for a day and returning with an incredible pile of drawings, among them one of a panther (since reproduced in " Colour ").

Wolmark and I are in agreement as to the degree of Gaudier's promise and genius. But Wolmark considers that Gaudier was at his best in " The Singer," and " The Seated Woman " (a work of about the same period).

He also thinks that Gaudier would have " returned to this sort of thing; that " if he had gone on he would have " come back " to this kind of work " or something like it."

This point of view is so opposed to my own that I feel myself hardly the person to set it forth. It would be unfair to the idea to represent it by my unsympathetic impression. I think it fair to state that this opinion exists, I cannot do much more for it.

If we define style as " the absolute subjugation of the details of a given work to the dominant will; to the central urge or impulse," then I admit that in " The Singer " and statues of that phase Gaudier had " style " in a sense which he hardly had it again until he came to the work which I shall later describe as " squarish and bluntish." But the phase of the " Singer " is to my mind by no means so interesting or significant as the " style " in the squarish and bluntish work or in the " Birds Erect."

(I am speaking of the statuary. The stag-drawings and the carvings of animals have " style," and are to me more interesting than the " Singer " or the drawings of human figures.)

Wolmark considers the later work " experimental "; and says that Gaudier regarded it as a " phase " not an end. I am not sure that there is any great work which is not " experimental." Some experiments land on " discovery," but they are none the less " experiments."

Personally I do not believe that " genius " ever " goes back." Any man who has ever made innovations or even reinstated a fine but mislaid tradition in any art knows that there are always people who want an artist to do and re-do the things he was doing the year before last. It would be a great impertinence for

me to pretend that I was in absolute unanimity with Gaudier. It is a great impertinence for any man to think he is in perfect agreement with any other.

It would be a very sickly sign for any man of twenty-two to regard his actual work as anything save a way and a leading toward some further fullness and rightness.

I do not believe any important artist knows what he is going to do five years hence, and I do not think any one else can know for him. I do not think good artists return later in life to do what they were doing at twenty.

It would be most unfair to Mr. Wolmark to interpret his phrase too literally, and he allows himself considerable liberty, or rather he guards against an academic prediction, by saying, " Work like the ' Singer ' and : ' Seated Woman ' phase, or something like it."

It is very hard to limit or give a precise meaning to the words " or something like it." Mr. Wolmark might find similarities where I should not. However, Mr. Wolmark's intuition of Gaudier's future is certainly very different from my own, and I wish to present the fact of this divergence as fairly as possible. He and certainly quite a number of people whom I cannot regard as imbeciles, prefer the work like the " Singer."

I and various people, who seem to me most alive to the significance of Gaudier's work, are interested in the squarish and bluntish period, Gaudier's latest work, the cut brass and the " Birds Erect."

Gaudier himself refers somewhere to "the usual Rodin-Maillol mixture." The Rodin admixture he had purged from his system when he quit doing representative busts of Frank Harris and Col. Smithers. Maillol I think went next. Epstein reigned for a time in his bosom; and then came the work which I can only refer to himself, to his own innovations, to his personal combinations of forms.

The animal drawings and carvings are neutral ground, and in them the only possible influence upon him was archaic. Fonts de Gaume and Chou bronzes, plus life itself and his genius, which was in this case an abnormal sympathy with, an intelligence for, all moving animal life, its swiftness and softness.

Respecting Epstein, I remember an amusing outbreak of

Gaudier's against Epstein's sloth : " Work ! ! Work ? I know he does not work. His hands are clean ! ! "

And Epstein, impassively, when he heard it : " Ugh, so I do not work? Well. I hope he works to some advantage."

There was another amusing afternoon with Gaudier when he held forth at length on the follies of a certain Fabbrucci. Fabbrucci is a sculptor of the academic variety who makes clay models for gas fixtures and copies Victorian pictures in stone with the aid of a drill. He is now doing the " Princes in the Tower " for some one with a large house full of plush furniture. Gaudier's definition of Fabbrucci's labours was detailed and vigorous, the text being, " How beautiful is the labour of doing a job in the wrong medium." Some of the cutting on this grand idiocy is of course very inconvenient, and as Gaudier said of one cavity, " He will be in that d . . . d hole for six months." (The " hole " being, I think, the cavity beneath the young prince's chair, or else the space between the two princes' doublets.)

It is almost needless to say that sculptors who do this sort of work are very prosperous persons in comparison with creative artists, discoverers and inventors.

Fabbrucci's opinion of Gaudier as quoted by the latter was that Gaudier's sculpture was " *not sculpture but stones.*"

XI

THERE are always people enough to praise a man during the few weeks after his death, and I therefore extract some meagre comfort from the fact that I am not among those who waited. There were the two articles in the *Egoist,* before mentioned. In September, 1914, I had an article in the *Fortnightly Review,* which was for the most part a closer form of a rather informal lecture given at the Rebel Art Centre in Ormond Street the preceding spring.

I reprint that article entire because it shows our grounds for agreement, or at least the train of thought which led to the use of the term " vorticist " when we wished a designation that would be equally applicable to a certain basis for all the arts. Obviously you cannot have " cubist " poetry or " imagist " painting.

I had put the fundamental tenet of vorticism in a " Vortex " in the first *Blast* as follows : —

Every concept, every emotion presents itself to the vivid consciousness in some primary form. It belongs to the art of this form. If sound, to music; if formed words, to literature; the image, to poetry; form, to design; colour in position, to painting; form or design in three planes, to sculpture; movement, to the dance or to the rhythm of music or verses.

I defined the vortex as " the point of maximum energy," and said that the vorticist relied on the " primary pigment," and on that alone.

These statements seemed to convey very little to people unfamiliar with our mode of thought, so I tried to make myself clear, as follows : —

VORTICISM

" IT is no more ridiculous that a person should receive or convey an emotion by means of an arrangement of shapes, or planes, or colours, than that they should receive or convey such emotion by an arrangement of musical notes."

I suppose this proposition is self-evident. Whistler said as much, some years ago, and Pater proclaimed that " All arts approach the conditions of music."

Whenever I say this I am greeted with a storm of " Yes, but " . . . s. " But why isn't this art futurism ? " " Why isn't? " " Why don't? " and above all : " What, in Heaven's name, has it got to do with your Imagiste poetry? "

Let me explain at leisure, and in nice, orderly, old-fashioned prose.

We are all futurists to the extent of believing with Guillaume Appollonaire that " On ne peut pas porter *partout* avec soi le cadavre de son père." But " futurism," when it gets into art, is, for the most part, a descendant of impressionism. It is a sort of accelerated impressionism.

There is another artistic descent *viâ* Picasso and Kandinsky; *viâ* cubism and expressionism. One does not complain of neo-impressionism or of accelerated impressionism and " simultaneity," but one is not wholly satisfied by them. One has perhaps other needs.

It is very difficult to make generalities about three arts at once. I shall be, perhaps, more lucid if I give, briefly, the history of the vorticist art with which I am most intimately connected, that is to say, vorticist poetry. Vorticism has been announced as including such and such painting and sculpture and " Imagisme " in verse. I shall explain " Imagisme," and then proceed to show its inner relation to certain modern paintings and sculpture.

Imagisme, in so far as it has been known at all, has been known chiefly as a stylistic movement, as a movement of criticism rather than of creation. This is natural, for, despite all possible celerity of publication, the public is always, and of necessity, some years behind the artists' actual thought. Nearly anyone is ready to accept " Imagisme " as a department of poetry, just as one accepts " lyricism " as a department of poetry.

There is a sort of poetry where music, sheer melody, seems as if it were just bursting into speech.

There is another sort of poetry where painting or sculpture seems as if it were " just coming over into speech."

The first sort of poetry has long been called " lyric." One

is accustomed to distinguish easily between " lyric " and " epic " and " didactic." One is capable of finding the " lyric " passages in a drama or in a long poem not otherwise " lyric." This division is in the grammars and school books, and one has been brought up to it.

The other sort of poetry is as old as the lyric and as honourable, but, until recently, no one had named it. Ibycus and Liu Ch'e presented the " Image." Dante is a great poet by reason of this faculty, and Milton is a wind-bag because of his lack of it. The " image " is the furthest possible remove from rhetoric. Rhetoric is the art of dressing up some unimportant matter so as to fool the audience for the time being. So much for the general category. Even Aristotle distinguishes between rhetoric, " which is persuasion," and the analytical examination of truth. As a " critical " movement, the " Imagisme " of 1912 to '14 set out " to bring poetry up to the level of prose." No one is so quixotic as to believe that contemporary poetry holds any such position. . . . Stendhal formulated the need in his *De L'Amour* :—

" La poésie avec ses comparaisons obligées, sa mythologie que ne croit pas le poète, sa dignité de style à la Louis XIV et tout l'attirail de ses ornements appelés poétique, est bien au dessous de la prose dès qu'il s'agit de donner une idée claire et précise des mouvements de cœur, or dans ce genre on n'émeut que par la clarté."

Flaubert and De Maupassant lifted prose to the rank of a finer art, and one has no patience with contemporary poets who escape from all the difficulties of the infinitely difficult art of good prose by pouring themselves into loose verses.

The tenets of the Imagiste faith were published in March, 1913, as follows :—

I. Direct treatment of the " thing," whether subjective or objective.

II. To use absolutely no word that does not contribute to the presentation.

III. As regarding rhythm : to compose in sequence of the musical phrase, not in sequence of the metronome.

There followed a series of about forty cautions to beginners, which need not concern us here.

The arts have indeed "some sort of common bond, some inter-recognition." Yet certain emotions or subjects find their most appropriate expression in some one particular art. The work of art which is most "worth while" is the work which would need a hundred works of any other kind of art to explain it. A fine statue is the core of a hundred poems. A fine poem is a score of symphonies. There is music which would need a hundred paintings to express it. There is no synonym for the *Victory of Samothrace* or for Mr. Epstein's flenites. There is no painting of Villon's *Frères Humains*. Such works are what we call works of the "first intensity."

A given subject or emotion belongs to that artist, or to that sort of artist who must know it most intimately and most intensely before he can render it adequately in his art. A painter must know much more about a sunset than a writer, if he is to put it on canvas. But when the poet speaks of "Dawn in russet mantle clad," he presents something which the painter cannot present.

I said in the preface to my *Guido Cavalcanti* that I believed in an absolute rhythm. I believe that every emotion and every phase of emotion has some toneless phrase, some rhythm-phrase to express it.

(This belief leads to *vers libre* and to experiments in quantitative verse.)

To hold a like belief in a sort of permanent metaphor is, as I understand it, "symbolism" in its profounder sense. It is not necessarily a belief in a permanent world, but it is a belief in that direction.

Imagisme is not symbolism. The symbolists dealt in "association," that is, in a sort of allusion, almost of allegory. They degraded the symbol to the status of a word. They made it a form of metonomy. One can be grossly "symbolic," for example, by using the term "cross" to mean "trial." The symbolist's *symbols* have a fixed value, like numbers in arithmetic, like 1, 2, and 7. The imagiste's images have a variable significance, like the signs a, b, and x in algebra.

Moreover, one does not want to be called a symbolist, because

symbolism has usually been associated with mushy technique.

On the other hand, Imagisme is not Impressionism, though one borrows, or could borrow, much from the impressionist method of presentation. But this is only negative definition. If I am to give a psychological or philosophical definition "from the inside," I can only do so autobiographically. The precise statement of such a matter must be based on one's own experience.

In the "search for oneself," in the search for "sincere self-expression," one gropes, one finds some seeming verity. One says "I am" this, that, or the other, and with the words scarcely uttered one ceases to be that thing.

I began this search for the real in a book called *Personae,* casting off, as it were, complete masks of the self in each poem. I continued in long series of translations, which were but more elaborate masks.

Secondly, I made poems like "The Return," which is an objective reality and has a complicated sort of significance, like Mr. Epstein's "Sun God," or Mr. Brzeska's "Boy with a Coney." Thirdly, I have written "Heather," which represents a state of consciousness, or "implies," or "implicates" it.

A Russian correspondent, after having called it a symbolist poem, and having been convinced that it was not symbolism, said slowly: "I see, you wish to give people new eyes, not to make them see some new particular thing."

These two latter sorts of poems are impersonal, and that fact brings us back to what I said about absolute metaphor. They are Imagisme, and in so far as they are Imagisme, they fall in with the new pictures and the new sculpture.

Whistler said somewhere in the *Gentle Art* : "The picture is interesting not because it is Trotty Veg, but because it is an arrangement in colour." The minute you have admitted that, you let in the jungle, you let in nature and truth and abundance and cubism and Kandinsky, and the lot of us. Whistler and Kandinsky and some cubists were set to getting extraneous matter out of their art; they were ousting literary values. The Flaubertians talk a good deal about "constatation." "The 'nineties" saw a movement against rhetoric. I think all these things move together, though they do not, of course, move in step.

The painters realise that what matters is form and colour. Musicians long ago learned that programme music was not the ultimate music. Almost anyone can realize that to use a symbol *with an ascribed or intended meaning* is, usually, to produce very bad art. We all remember crowns, and crosses, and rainbows, and what not in atrociously mumbled colour.

The image is the poet's pigment.* The painter should use his colour because he sees it or feels it. I don't much care whether he is representative or non-representative. He should *depend,* of course, on the creative, not upon the mimetic or representational part in his work. It is the same in writing poems, the author must use his *image* because he sees it or feels it, *not* because he thinks he can use it to back up some creed or some system of ethics or economics.

An *image,* in our sense, is real because we know it directly. If it have an age-old traditional meaning this may serve as proof to the professional student of symbology that we have stood in the deathless light, or that we have walked in some particular arbour of his traditional paradiso, but that is not our affair. It is our affair to render the *image* as we have perceived or conceived it.

Browning's " Sordello " is one of the finest *masks* ever presented. Dante's " Paradiso " is the most wonderful *image.* By that I do not mean that it is a perseveringly imagistic performance. The permanent part is Imagisme, the rest, the discourses with the calendar of saints and the discussions about the nature of the moon, are philology. The form of sphere above sphere, the varying reaches of light, the minutiæ of pearls upon foreheads, all these are parts of the Image. The image is the poet's pigment; with that in mind you can go ahead and apply Kandinsky, you can transpose his chapter on the language of form and colour and apply it to the writing of verse. As I cannot rely on your having read Kandinsky's *Ueber das Geistige in der Kunst,* I must go on with my autobiography.

Three years ago in Paris I got out of a " metro " train at La Concorde, and saw suddenly a beautiful face, and then another and another, and then a beautiful child's face, and then another

* The image has been defined as " that which presents an intellectual and emotional complex in an instant of time."

beautiful woman, and I tried all that day to find words for what this had meant to me, and I could not find any words that seemed to me worthy, or as lovely as that sudden emotion. And that evening, as I went home along the Rue Raynouard, I was still trying and I found, suddenly, the expression. I do not mean that I found words, but there came an equation . . . not in speech, but in little splotches of colour. It was just that—a "pattern," or hardly a pattern, if by "pattern" you mean something with a "repeat" in it. But it was a word, the beginning, for me, of a language in colour. I do not mean that I was unfamiliar with the kindergarten stories about colours being like tones in music. I think that sort of thing is nonsense. If you try to make notes permanently correspond with particular colours, it is like tying narrow meanings to symbols.

That evening, in the Rue Raynouard, I realized quite vividly that if I were a painter, or if I had, often, *that kind* of emotion, or even if I had the energy to get paints and brushes and keep at it, I might found a new school of painting, of "non-representative" painting, a painting that would speak only by arrangements in colour.

And so, when I came to read Kandinsky's chapter on the language of form and colour, I found little that was new to me. I only felt that some one else understood what I understood, and had written it out very clearly. It seems quite natural to me that an artist should have just as much pleasure in an arrangement of planes or in a pattern of figures, as in painting portraits of fine ladies, or in portraying the Mother of God as the symbolists bid us.

When I find people ridiculing the new arts, or making fun of the clumsy odd terms that we use in trying to talk of them amongst ourselves; when they laugh at our talking about the "ice-block quality" in Picasso, I think it is only because they do not know what thought is like, and that they are familiar only with argument and gibe and opinion. That is to say, they can only enjoy what they have been brought up to consider enjoyable, or what some essayist has talked about in mellifluous phrases. They think only "the shells of thought," as De Gourmont calls them; the thoughts that have been already thought out by others.

Any mind that is worth calling a mind must have needs beyond the existing categories of language, just as a painter must have pigments or shades more numerous than the existing names of the colours.

Perhaps this is enough to explain the words in my " Vortex "* :—

" Every concept, every emotion, presents itself to the vivid consciousness in some primary form. It belongs to the art of this form."

That is to say, my experience in Paris should have gone into paint. If instead of colour I had perceived sound or planes in relation, I should have expressed it in music or in sculpture. Colour was, in that instance, the " primary pigment "; I mean that it was the first adequate equation that came into consciousness. The Vorticist uses the " primary pigment." Vorticism is art before it has spread itself into flaccidity, into elaboration and secondary applications.

What I have said of one vorticist art can be transposed for another vorticist art. But let me go on then with my own branch of vorticism, about which I can probably speak with greater clarity. All poetic language is the language of exploration. Since the beginning of bad writing, writers have used images as ornaments. The point of Imagisme is that it does not use images *as ornaments*. The image is itself the speech. The image is the word beyond formulated language.

I once saw a small child go to an electric light switch and say, " Mamma, can I *open* the light? " She was using the age-old language of exploration, the language of art. It was a sort of metaphor, but she was not using it as ornamentation.

One is tired of ornamentations, they are all a trick, and any sharp person can learn them.

The Japanese have had the sense of exploration. They have understood the beauty of this sort of knowing. A Chinaman said long ago that if a man can't say what he has to say in twelve lines he had better keep quiet. The Japanese have evolved the still shorter form of the *hokku*.

> " The fallen blossom flies back to its branch :
> A butterfly."

* Appearing in the July number of *Blast*.

That is the substance of a very well-known *hokku*. Victor Plarr tells me that once, when he was walking over snow with a Japanese naval officer, they came to a place where a cat had crossed the path, and the officer said, " Stop, I am making a poem." Which poem was, roughly, as follows :—

> "The footsteps of the cat upon the snow:
> (are like) plum-blossoms."

The words " are like " would not occur in the original, but I add them for clarity.

The " one image poem " is a form of super-position, that is to say, it is one idea set on top of another. I found it useful in getting out of the impasse in which I had been left by my metro emotion. I wrote a thirty-line poem, and destroyed it because it was what we call work " of second intensity." Six months later I made a poem half that length; a year later I made the following *hokku*-like sentence :—

> "The apparition of these faces in the crowd:
> Petals, on a wet, black bough."

I dare say it is meaningless unless one has drifted into a certain vein of thought.* In a poem of this sort one is trying to record the precise instant when a thing outward and objective transforms itself, or darts into a thing inward and subjective.

This particular sort of consciousness has not been identified with impressionist art. I think it is worthy of attention.

The logical end of impressionist art is the cinematograph. The state of mind of the impressionist tends to become cinematographical. Or, to put it another way, the cinematograph does away with the need of a lot of impressionist art.

There are two opposed ways of thinking of a man : firstly, you may think of him as that toward which perception moves, as the toy of circumstance, as the plastic substance *receiving* impressions; secondly, you may think of him as directing a certain fluid force against circumstance, as *conceiving* instead of merely reflecting and observing. One does not claim that one way is

* Mr. Flint and Mr. Rodker have made longer poems depending on a similar presentation of matter. So also have Richard Aldington, in his *In Via Sestina,* and " H. D." in her *Oread,* which latter poems express much stronger emotions than that in my lines here given. Mr. Hueffer gives an interesting account of a similar adventure of his own in his review of the Imagiste anthology.

better than the other, one notes a diversity of the temperament. The two camps always exist. In the 'eighties there were symbolists opposed to impressionists, now you have vorticism, which is, roughly speaking, expressionism, neo-cubism, and imagism gathered together in one camp and futurism in the other. Futurism is descended from impressionism. It is, in so far as it is an art movement, a kind of accelerated impressionism. It is a spreading, or surface art, as opposed to vorticism, which is intensive.

The vorticist has not this curious tic for destroying past glories. I have no doubt that Italy needed Mr. Marinetti, but he did not set on the egg that hatched me, and as I am wholly opposed to his æsthetic principles I see no reason why I, and various men who agree with me, should be expected to call ourselves futurists. We do not desire to evade comparison with the past. We prefer that the comparison be made by some intelligent person whose idea of " the tradition " is not limited by the conventional taste of four or five centuries and one continent.

Vorticism is an intensive art. I mean by this, that one is concerned with the relative intensity, or relative significance of different sorts of expression. One desires the most intense, for certain forms of expression *are* " more intense " than others. They are more dynamic. I do not mean they are more emphatic, or that they are yelled louder. I can explain my meaning best by mathematics.

There are four different intensities of mathematical expression known to the ordinarily intelligent undergraduate, namely: the arithmetical, the algebraic, the geometrical, and that of analytical geometry.

For instance, you can write
$$3 \times 3 + 4 \times 4 = 5 \times 5,$$
$$\text{or differently, } 3^2 + 4^2 = 5^2.$$
That is merely conversation or " ordinary common sense." It is a simple statement of one fact, and does not implicate any other.

Secondly, it is true that
$$3^2 + 4^2 = 5^2, \ 6^2 + 8^2 = 10^2, \ 9^2 + 12^2 = 15^2, \ 39^2 + 52^2 = 65^2.$$
These are all separate facts, one may wish to mention their underlying similarity; it is a bore to speak about each one in turn. One expresses their " algebraic relation " as $a^2 + b^2 = c^2$.

That is the language of philosophy. It MAKES NO
PICTURE. This kind of statement applies to a lot of facts, but
it does not grip hold of Heaven.

Thirdly, when one studies Euclid one finds that the relation
of $a^2 + b^2 = c^2$ applies to the ratio between the squares on the
two sides of a right-angled triangle and the square on the hypo-
tenuse. One still writes it $a^2 + b^2 = c^2$, but one has begun to
talk about form. Another property or quality of life has crept
into one's matter. Until then one had dealt only with numbers.
But even this statement does not *create* form. The picture is
given you in the proposition about the square on the hypotenuse
of the right-angled triangle being equal to the sum of the
squares on the two other sides. Statements in plane or descriptive
geometry are like talk about art. They are a criticism of the
form. The form is not created by them.

Fourthly, we come to Descartian or " analytical geometry."
Space is conceived as separated by two or by three axes (depend-
ing on whether one is treating form in one or more planes). One
refers points to these axes by a series of co-ordinates. Given the
idiom, one is able *actually to create.*

Thus, we learn that the equation $(x - a)^2 + (y - b)^2 = r^2$
governs the circle. It is the circle. It is not a particular circle, it
is any circle and all circles. It is nothing that is not a circle. It
is the circle free of space and time limits. It is the universal,
existing in perfection, in freedom from space and time. Mathe-
matics is dull ditchwater until one reaches analytics. But in
analytics we come upon a new way of dealing with form. It is
in this way that art handles life. The difference between art and
analytical geometry is the difference of subject-matter only. Art
is more interesting in proportion as life and the human conscious-
ness are more complex and more interesting than forms and
numbers.

This statement does not interfere in the least with " spon-
taneity " and " intuition," or with their function in art. I passed
my last *exam.* in mathematics on sheer intuition. I saw where
the line *had* to go, as clearly as I ever saw an image, or felt
caelestem intus vigorem.

The statements of " analytics " are " lords " over fact. They
are the thrones and dominations that rule over form and recur-

rence. And in like manner are great works of art lords over fact, over race-long recurrent moods, and over to-morrow.

Great works of art contain this fourth sort of equation. They cause form to come into being. By the " image " I mean such an equation; not an equation of mathematics, not something about *a, b,* and *c,* having something to do with form, but about *sea, cliffs, night,* having something to do with mood.

The image is not an idea. It is a radiant node or cluster; it is what I can, and must perforce, call a VORTEX, from which, and through which, and into which, ideas are constantly rushing. In decency one can only call it a VORTEX. And from this necessity came the name " vorticism." *Nomina sunt consequentia rerum,* and never was that statement of Aquinas more true than in the case of the vorticist movement.

It is as true for the painting and the sculpture as it is for the poetry. Mr. Wadsworth and Mr. Lewis are not using words, they are using shape and colour. Mr. Brzeska and Mr. Epstein are using " planes in relation," they are dealing with a relation of planes different from the sort of relation of planes dealt with in geometry, hence what is called " the need of organic forms in sculpture."

I trust I have made clear what I mean by an " intensive art." The vorticist movement is not a movement of mystification, though I dare say many people " of good will " have been considerably bewildered.

The organization of forms is a much more energetic and creative action than the copying or imitating of light on a haystack.

There is undoubtedly a language of form and colour. It is not a symbolical or allegorical language depending on certain meanings having been ascribed, in books, to certain signs and colours.

Certain artists working in different media have managed to understand each other. They know the good and bad in each other's work, which they could not know unless there were a common speech.

As for the excellence of certain contemporary artists, all I can do is to stand up for my own beliefs. I believe that Mr. Wyndham Lewis is a very great master of design; that he has brought

into our art new units of design and new manners of organisation. I think that his series " Timon " is a great work. I think he is the most articulate expression of my own decade. If you ask me what his " Timon " means, I can reply by asking you what the old play means. For me his designs are a creation on the same *motif*. That *motif* is the fury of intelligence baffled and shut in by circumjacent stupidity. It is an emotional *motif*. Mr. Lewis's painting is nearly always emotional.

Mr. Wadsworth's work gives me pleasure, sometimes like the pleasure I have received from Chinese and Japanese prints and painting; for example, I derive such pleasure from Mr. Wadsworth's " Khaki." Sometimes his work gives me a pleasure which I can only compare to the pleasure I have in music, in music as it was in Mozart's time. If an outsider wishes swiftly to understand this new work, he can do worse than approach it in the spirit wherein he approaches music.

" Lewis is Bach." No, it is incorrect to say that " Lewis is Bach," but our feeling is that certain works of Picasso and certain works of Lewis have in them something which is to painting what certain qualities of Bach are to music. Music was vorticist in the Bach-Mozart period, before it went off into romance and sentiment and description. A new vorticist music would come from a new computation of the mathematics of harmony, not from a mimetic representation of dead cats in a fog-horn, alias noise-tuners.

Mr. Epstein is too well known to need presentation in this article. Mr. Brzeska's sculpture is so generally recognized in all camps that one does not need to bring in a brief concerning it. Mr. Brzeska has defined sculptural feeling as " the appreciation of masses in relation," and sculptural ability as " the defining of these masses by planes." There comes a time when one is more deeply moved by that form of intelligence which can present " masses in relation " than by that combination of patience and trickery which can make marble chains with free links and spin out bronze until it copies the feathers on a general's hat. Mr. Etchells still remains more or less of a mystery. He is on his travels, whence he has sent back a few excellent drawings. It cannot be made too clear that the work of the vorticists and the " feeling of inner need " existed before the general noise about

vorticism. We worked separately, we found an underlying agreement, we decided to stand together.

<div align="right">EZRA POUND.</div>

NOTE.

I am often asked whether there can be a long imagiste or vorticist poem The Japanese, who evolved the hokku, evolved also the Noh plays. In the best " Noh " the whole play may consist of one image. I mean it is gathered about one image. Its unity consists in one image, enforced by movement and music. I see nothing against a long vorticist poem.

On the other hand, no artist can possibly get a vortex into every poem or picture he does. One would like to do so, but it is beyond one. Certain things seem to demand metrical expression, or expression in a rhythm more agitated than the rhythms acceptable to prose, and these subjects, though they do not contain a vortex, may have some interest, an interest as " criticism of life " or of art. It is natural to express these things, and a vorticist or imagiste writer may be justified in presenting a certain amount of work which is not vorticism or imagisme, just as he might be justified in printing a purely didactic prose article. Unfinished sketches and drawings have a similar interest; they are trials and attempts toward a vortex.

XII

In the following January and February I had further opportunity for recording some of my thoughts on sculpture. I wrote rather bad temperedly in the *New Age* and was duly abused for it. There was one article on Epstein and another on Brzeska in a series of articles on the art of our decade. Mention of Brzeska is so mixed into the Epstein article that I print the two of them almost entire.

I wrote* that the "nation," or, rather, the art critics and editorial writers of the orthodox press, had been prostrating themselves before M. Rodin and offering their pæans of praise. M. Rodin had made a very generous gift to England. To be sure, some of his sculpture seems made rather to please bankers with pink satin minds than to stir the lover of fine art; but even so, it was not for any loyal Englishman to mention the fact at this moment. And, moreover, M. Rodin has been the most striking figure in his generation of sculptors, and it is not proper to pluck at the beards of old men, especially when they are doing fine things.

The beard which one wishes to pluck is the collective beard of the English curators who did not realize Rodin in his best period, and who have left this island without examples of his best work. It is, of course, too late to mend the matter with Rodin; we must, as the *Times* says, look into the future. It would be at least sensible to take some count of the present. Whatever may be the ultimate opinion concerning their respective genius, there can be no doubt whatsoever that the work now being done by Jacob Epstein is better than anything which is likely to be accomplished by Rodin at the age of one hundred and three.

Yet I learn from fairly reliable sources that that sink of abomination, the "Tate Gallery," has not bought any work of Epstein's (and its funds are, I believe, supposed to be used in acquiring representative modern art), but it has rushed further into the sloughs of stupidity by refusing, in an indirect manner

* "Affirmations," III., *New Age,* Jan. 21, 1915.

perhaps, yet refusing, one of the best of Epstein's works when it was offered as a gift. This is, to put it mildly, robbing the public.*

It may be answered that the public don't care. And the counter reply is that : the public don't know. Moreover, there is no surety that the public of fifty years hence will be plunged in a stupidity exactly identical with the present public stupidity. And besides all this, it is ridiculous even for the defenders of stupidity to pretend that there is not already a considerable part of the public who are " ready for Epstein."

The sculptors of England, with the exception of Epstein, are, or were until the beginning of the war, we suppose, engaged wholly in making gas-fittings and ornaments for electric light globes, etc. At least, we have little to prove the contrary. Of course, there's a living in it. And if people still want what Dublin calls " those beautiful productions displayed in the windows of our city art shops," one can only commend the soundness of certain commercial instincts. God forbid that we should interfere with any man's honest attempt to earn his sustenance. At the same time, there is a slender but, nevertheless, determined cult of the " creative element." A few, we say regretfully " a few," of us believe in the mobility of thought. We believe that human dignity consists very largely in humanity's ability to invent. One is, to put it mildly, weary with sculpture which consists of large, identical, allegorical ladies in night-gowns holding up symbols of Empire or Commerce or Righteousness, and bearing each one a different name, like " Manchester " or " Pittsburg," or " Justitia." One can no longer feel that they are a full expression of what Kandinsky calls the " inner need." They are perhaps " classic ornament," and if one did not disapprove of having decorative columns made by the gross, one might irreverently suggest that such statues be made by the gross, with detachable labels. Unfortunately, one does not believe in having even columns made by the gross; one has the tradition that columns should be hand-cut and signed. It is only so that one can have really fine buildings. One's loftiest wish is that the mimetic sculptors should be set to making columns, and that the

* I do not accuse Mr. Aitkin, I accuse the parties responsible, whatever may be their exquisite anonymity.

making of fine columns should be held in greater honour than the making of silly academy sculpture. The limits of the convention of columns and capitals might perhaps so press upon the mimetic sculptors as to result in something approaching intensity.

Of course, you will never awaken a general or popular art sense so long as you rely solely on the pretty, that is, the " caressable." We all of us like the caressable, but we most of us in the long run prefer the woman to the statue. That is the romance of Galatea. We prefer—if it is a contest in caressabilities—we prefer the figure in silk on the stairs to the " Victory " aloft on her pedestal-prow. We know that the " Victory " will be there whenever we want her, and that the young lady in silk will pass on to the Salon Carré, and thence on toward the unknown and unfindable. That is the trouble with the caressable in art. The caressable is always a substitute.

Ideals of the caressable vary. In Persia, the Persia of its romances, the crown of beauty, male or female. goes to him or her whose buttocks have the largest dimensions. And we all remember the Hindoo who justified his desire for fatness with the phrase " same money, more wife."

Ideals change, even the ideals of the caressable are known to have altered. Note, for example, the change in the ballet and in " indecent " illustrations. Twenty years ago, the ideal was one with large hips and bosom. To-day the ideal is more " svelte." The heavier types appear only in very " low " papers. In fact, the modern ideal approaches more nearly to the " Greek type," which is, as Pater says, disappointing " to all save the highest culture." The development of Greek sculpture is simple; it moves steadily towards the caressable. One may even say that people very often set up Greek art as an ideal because they are incapable of understanding any other.

The weakness of the caressable work of art, of the work of art which depends upon the caressability of the subject, is, incidentally, that its stimulativeness diminishes as it becomes more familiar. The work which depends upon an arrangement of forms becomes more interesting with familiarity in proportion as its forms are well organized. That is to say, the ideal vorticist is not the man of delicate incapabilities, who, being unable to get anything from life, finds himself reduced to taking a substitute in art.

Our respect is not for the subject-matter, but for the creative power of the artist; for that which he is capable of adding to his subject from himself; or, in fact, his capability to dispense with external subjects altogether, to create from himself or from elements. We hold that life has its own satisfactions, and that after a man has lived life up to the hilt, he should still have sufficient energy to go on to the satisfactions of art, which are different from the satisfactions of life. I will not say loftily : they are beyond it. The satisfactions of art differ from the satisfactions of life as the satisfactions of seeing differ from the satisfactions of hearing. There is no need to dispense with either. The artist who has no " ideas about art," like the man who has no ideas about life, is a dull dog.

The result of the attempt to mix the satisfactions of art and life is, naturally, muddle. There is downright *bad* art where the satisfactions offered or suggested are solely the satisfactions of life; for example, the drawings in salacious " comics " or the domesticities of " Pear's Annual "—that Mecca of British Academicians. There is art, often very fine art, of mixed appeal : for example, in Rodin's " La Vieille Heaulmière," the " beauty " of the work depends in no appreciable degree on the subject, which is " hideous." The " beauty " is from Rodin. It is in the composition, as I remember it; in silhouettes. The " interest " is, largely, a life interest or a sentimental interest. It is a pathos for lost youth, etc., intensified by a title reminiscent of Villon. Without the title from Villon the bronze loses much of its force.

If you measure art by its emotional effect scarcely anyone will deny that Villon's poem is more efficient than the statue. It calls up an image no less vivid. And it is easier to carry about in one's pocket, or in one's memory, for that matter. The words are, in fact, nearly unforgettable, while it is very hard to conserve more than a blurr or general impression of the bronze figure. Of course there is no denying that certain figures, more or less caressable, may have an artistic appeal based on " pure form "; on their composition and symmetry and balance, etc. Those who appreciate them on these grounds are nearer art than those who do not.

So far as I am concerned, Jacob Epstein was the first person who came talking about " form, not the *form of anything*." It

98

may have been Mr. T. E. Hulme, quoting Epstein. I don't know that it matters much who said it first; he may have been a theorist with no more than a sort of scientific gift for discovery. He may have been a great sculptor capable of acting out his belief. However that may be, the acceptable doctrine of my generation is that :

" Sculptural feeling is the appreciation of masses in relation.

" Sculptural ability is the defining of these masses by planes." —(Gaudier-Brzeska, in *Blast*.)

It is in accordance with this belief that one honours Epstein, apart entirely from one's sympathy or unsympathy with any particular work.

" Cynthia prima fuit? " what does it matter? Epstein is a " slow worker," perhaps. His mind works with the deliberation of the chisel driving through stone, perhaps. The work is conceived from the beginning, slow stroke by slow stroke, like some prehistoric, age-long upheaval in natural things, driven by natural forces . . . full of certitude and implacable and unswerving . . . perhaps. And perhaps these are only phrases and approximations and rhetoric. They are the sort of phrases that arise in the literary mind in the presence of Epstein's sculpture. At any rate we do not say " Here is a man who ought to have been writing a comedy of manners." We feel convinced that it is a man fit for his job.

Let me be quite definite about what I mean by the work of Jacob Epstein—the work as I know it consists of :

" The Strand Statues " (which are very early).

The Wilde Memorial (which is over-ornate, and which one, on the whole, rather dislikes).

A scrawny bronze head, more or less early renaissance, quite fine, and which Mr. Epstein will reprove me for praising. He always reproves you for liking the " work before last."

Head of a boy, in bright copper, or some such substance. That is to say, the top and back are burnished.

Head of an infant (quite representational).

The Sun-God.

Two sets of pigeons. The heavier and closer is the better.

The two flenites, the finest work of the lot.

A bird preening itself (graceful).

The rock-drill.*

And in this dozen works there are three or four separate dona-
tions. One wonders how many great artists have been as tem-
perate; how many have waited for such a degree of certitude
before they ventured to encumber the earth with " yet another
work of art." Surely there are two types of mind which the
mediocre world hates most. There is this mind of the slow gesta-
tion, whose absoluteness terrifies " the man in the street."
Roughly speaking, it is the neglected type of Buonarroti. There
is the type " Leonardo," that follows the lightning for model,
that strikes now here, now there with bewildering rapidity, and
with a certitude of its own. The first type is escapable, or at
least, temporarily evadable. You cannot contradict the man's
affirmations, but you can at least leave him alone in his corner.
You can kill time and avoid looking things in the face. This
type is, let us say, the less alarming. The second type is, I
suppose, the most hated; that is to say, the most feared. You
never know where the man will turn up. You never know what
he will do next, and, for that matter, when he won't do some-
thing or other better than you can, or pierce your belovédest
delusion. The first type is crowned in due course, the second
type, never till death. After Leonardo is dead professors can
codify his results. They can produce a static dogma and return
in peace to their slumbers.

I beg you may pardon digressions, but is it or is it not
ludicrous that " The Sun-God " (and two other pieces which I
have not seen) should be pawned, the whole lot, for some £60?
And that six of the other works are still on the sculptor's hands?
And this is not due to the war. It was so before this war was
heard of.

One looks out upon American collectors buying autograph
MSS. of William Morris, faked Rembrandts and faked Van-

* This is, of course, not a full catalogue of Epstein's work, merely the few
pieces on which I based my criticism.

dykes. One looks out on a plutocracy and upon the remains of an aristocracy who ought to know by this time that keeping up the arts means keeping up living artists; that no age can be a great age which does not find its own genius. One sees buildings of a consummate silliness; buildings which are beautiful before they are finished, enchanting when they consist only of foundations and of a few great scaffoldings and cranes towering into the day or into the half-darkness. When they are finished they are a mass of curley-cues and " futile adornments." Because?

Because neither America nor England cares enough to elevate great men to control; because there is no office for the propagation of form; because there is no power to set Epstein, for example, where he should be, to wit, in some place where his work would be so prominent that people, and even British architects, would be forced to think about form. Of course, some of them do think about form; and then, after they have constructed a fine shape, go *gaga* with ornaments.

I do not mean by this that I would make Epstein an inspector of buildings, or that I would set him to supervise architects' plans. The two arts are different, though they both deal with three dimensional form. I mean simply that a contemplation of Epstein's work would instil a sense of form in the beholder. That is, perhaps, the highest thing one can say of a sculptor.

All this is very secondary and literary and sociological. There could be no such harangue among artists. One sees the work; one knows; or, even, one feels.

Trying to find some praise that shall be exact and technical, some few of us, not sculptors, but admirers, would turn to Brzeska's " Vortex," which will be undoubtedly the first textbook of sculpture in many academies before our generation has passed from this earth. Accepting his terminology we would say : Epstein has worked with the sphere, and with the cylinder. He has had " form-understanding "; he has not fallen into the abyss, into the decadence of all sculpture which is " the admiration of self."

Why should we try to pin labels on " what he has expressed"? Is there any profit in saying that his form-organisations express facts which were perhaps more violently true for the south-sea islander of three thousand years ago than for us, who are

moderns? That sort of talk is mostly nonsense. It is the artist's job to express what is " true for himself." In such measure as he does this he is a good artist, and, in such measure as he himself exists, a great one.

As for " expressing the age," surely there are five thousand sculptors all busy expressing the inanities, the prettinesses, the sillinesses—the Gosses and Tademas, the Mayfairs and Hampsteads of the age. Of course the age is " not so bad as all that." But the man who tries to express his age, instead of expressing himself, is doomed to destruction.

But this, also, is a side track. I should not spend my lines in answering carpings. I should pile my objectives upon Epstein, or, better still, I should ask my opponents to argue, not with me, but to imagine themselves trying to argue with one of the Flenites, or with the energies of his " Sun-God." They'd " teach you to " talk about " expressing your age," and being the communal trumpet.

The test of a man is not the phrases of his critics; the test lies in the work, in its " certitude." What answer is to be made to the " Flenites "? With what sophistry will you be able to escape their assertion?

AFFIRMATIONS *

GAUDIER-BRZESKA

IT may suit some of my friends to go about with their young noses pointing skyward, decrying the age and comparing us unfavourably to the dead men of Hellas or of Hesperian Italy. And the elders of my acquaintance may wander in the half-lights complaining that—
 Queens have died young and fair.
But I, for one, have no intention of decreasing my enjoyment of this vale of tears by under-estimating my own generation. The uncertainty regarding the number of lives allowed one is too great. Neither am I so jealous of other men's reputations that I must wait until they are dead before I will praise them.

Having written this, I turn to " Il Cortegiano," " that

* *New Age*, February 4th, 1915.

great book of courtesies " which I have never yet been able to read from cover to cover. I find the Italian contemporaries of your King Henry VII already wrangling over feminism and supermen, over democracies and optimates and groups and herds : abstract topics which lead in the end to Polonius. They speak of the " white man's burden " and of the rational explanation of myths, and they talk about "the light of Christian truth " (in that phrase precisely).

The discourse is perhaps more readable when Cardinal Bibiena questions whether or no a perfect gentleman should carry a joke to the point of stealing a countryman's capons. The prose is musical and drowsy, so that if you read the Italian side of the page you feel no need of Paul Fort. (I am turning aside from the very reverent bilingual version of 1727.) The periods are perhaps more musical than the strophes of the modern prose poems. One reads on aloud until one's voice is tired, and finds one has taken in nothing. Or perhaps you awake at a paragraph which says :—

" Alexander the Great . . . built Alexandria in Egypt . . . Bucephalia, etc. And he had Thoughts also of reducing Mount Athos into the Shape of a Man. To raise on his left Hand a most ample City, and in his right to dig a large Bason, in which he designed to make a Conflux of all the Rivers, which flow'd from the Mountain, and from thence tumble them into the Sea; a Project truly noble, and worthy of the Great Alexander."

Perhaps, even, you persevere to the final discourse of Bembo on the nature of love and beauty, with its slightly stagey reminiscence of the Socratic trance. It is here that he calls beauty the sign manifest and insignia of the past victories of the soul. But for all their eloquence, for all the cradling cadences of the Italian speech, I find nothing to prove that the conversation at Urbino was any better than that which I have heard in dingy studios or in restaurants about Soho. I feel that Urbino was charming, that the scene is worthy of Veronese; and especially I feel that no modern ambassador or court functionary could write half so fine a book as " Il Cortegiano." This proves nothing more nor less than that good talk and wide interest have abandoned court circles and taken up their abode in the studios, *in quadriviis et angiportis.*

Et in quadriviis et angiportis we have new topics, new ardours. We have lost the idolatry for the Greek which was one of the main forces of the Renaissance. We have kept, I believe, a respect for what was strong in the Greek, for what was sane in the Roman. We have other standards, we have gone on with the intentions of Pico, to China and Egypt.

The man among my friends who is loudest in his sighs for Urbino, and for lost beauty in general, has the habit of abusing modern art for its " want of culture." As a matter of fact, it is chiefly the impressionists he is intent on abusing, but like most folk of his generation, he " lumps the whole lot together." He says : They had no traditions and no education, and therefore they created an art that needed no introductory knowledge. This means that he separates the " impressionist " painters from the impressionist writers, but let that pass. Let us say that Manet and Monet and Renoir had no education; that the tradition of Crivelli's symbols meant less to them than the rendering of light and shadow. I shall not stop admiring their paintings. I shall not, for any argument whatsoever, cease to admire the work of minds creative and inventive in whatsoever form it may come or may have come. Nor, on the other hand, will I ever be brought to consider futurism as anything but gross cowardice. It may be that Italy was so sick that no other medicine could avail, but for any man, not a modern Italian, to shirk comparison with the best work of the past is gross cowardice. The Italian may shirk if he likes, but he will remain a parochial celebrity even so.

Urbino was charming for the contemporaries of Count Baldassar Castiglione. Most of Urbino's topics, not all, thank heaven, have been relegated to the " New Statesman." The Lord Michael Montaigne no longer keeps a conceited, wise notebook in private. " We " keep our journals in public print, and when we go wrong or make a side-slip, we know it, we " hear of it," we receive intimations. I don't know that it matters. I am not even sure that we have lost the dignity of letters thereby, though we have lost the quiet security.

To return to the symboliste friend, I am not going to bother arguing the case for deceased impressionists; his phrase was that all " modern art " was the art of the ignorant; of the people who

despised tradition not because they knew enough to know how far tradition might or might not be despicable, but who despised it without knowing what it was. I shall let other modern movements shift for themselves. But to bring such a charge against a movement having for one of its integral members Gaudier-Brzeska, is arrant nonsense.

Here is a man as well furnished with catalogued facts as a German professor, of the old type, before the war-school; a man who knows the cities of Europe, and who knows not merely the sculpture out of Reinach's Apollo but who can talk and think in the terms of world-sculpture and who is for ever letting out odd packets of knowledge about primitive African tribes or about Babylonia and Assyria, substantiated by quotations from the bulkiest authors, and who, moreover, carries this pack without pedantry and unbeknown to all save a few intimates.

Take, if you like, four typical vorticists : there is Brzeska, and another man digging about in recondite early woodcuts or in studies of Chinese painting, and another man mad about Korin, and another man whom even *The Spectator* has referred to as "learned." If these men set out to " produce horrors," obviously it is not from ignorance or from lack of respect for tradition. No. The sum of their so-called revolt is that they refuse to recognize parochial borders to the artistic tradition. That they think it not enough to be the best painter in Chelsea, S.W., or to excel all the past artists of Fulham. " Speak of perfection, my songs, and you will find yourselves exceedingly disliked." Vorticism refuses to discard any part of the tradition merely because it is a difficult bogey; because it is difficult perhaps to be as good a designer as Dürer, and is consequently more convenient to pretend that " the element of design is not so important."

There is another shibboleth of the artistic-slop crowd. It is the old cry about intellect being inartistic, or about art being " above," saving the word, " above " intellect. Art comes from intellect stirred by will, impulse, emotion, but art is emphatically not any of these others deprived of intellect, and out drunk on its 'lone, saying it is the " that which is beyond the intelligence."

There are, as often has been said, two sorts of artists : the artist who moves through his art, to whom it is truly a

" medium " or a means of expression; and, secondly, there is the mediumistic artist, the one who can only exist in his art, who is passive to impulse, who approaches more or less nearly to the " sensitive," or to the somnambulistic " medium." The faculty of this second type is most useful as a part of the complete artist's equipment. And I do not hesitate to call Brzeska " complete artist." In him there is sculptural ability. That goes without saying. And there is " equipment " in the sense of wide knowledge of his art and of things outside it, and there is intellect. There is the correlating faculty, an ability to " arrange in order " not only the planes and volumes which are peculiarly *of* his art, but an ability for historical synthesis, an ability for bringing order into things apparently remote from the technique of his art.

In my paper on Epstein I referred to Brzeska's " Vortex " in *Blast*. It is not merely a remarkable document from a man whom people remember a twelve-month before as speaking English with difficulty, it is a remarkable arrangement of thought. I confess that I read it two or three times with nothing but a gaiety and exhilaration arising from the author's vigour of speech.

" They elevated the sphere in a splendid squatness and created the Horizontal.

" From Sargon to Amir-nasir-pal men built man-headed bulls in horizontal flight-walk. Men flayed their captives alive and erected howling lions : The Elongated Horizontal Sphere Buttressed on Four Columns, and their kingdoms disappeared."

I read that passage many times for the sake of its oratorical properties without bothering much for the meaning. Then a friend who detests vorticism but who " has to admire Gaudier-Brzeska," said rather reluctantly : " He has put the whole history of sculpture in three pages." It is quite true. He has summarised the whole history of sculpture. I said he had the knowledge of a German professor, but this faculty for synthesis is most untedescan.

The Paleolithic vortex, man intent upon animals. The Hamite vortex, Egypt, man in fear of the gods. The derivative Greek. The Semitic Vortex, lust of war. Roman and later decadence, Western sculpture, each impulse with corresponding effects on

form. In like manner he analyses the Chinese and Mexican and Oceanic forms. The sphere, the vertical, the horizontal, the cylinder and the pointed cone; and then the modern movement.

Naturally this means nothing to anyone who has not thought about sculpture; to anyone who has not tried to think why the official sculpture is so deadly uninteresting.

" Sculptural energy is the mountain."

" Sculptural feeling is the appreciation of masses in relation."

" Sculptural ability is the defining of these masses by planes."

I repeat what I said before; this Vortex Gaudier-Brzeska, which is the last three pages of *Blast* (the first number), will become the text-book in all academies of sculpture before our generation has passed from the earth. If *Blast* itself were no more than an eccentrically printed volume issued by a half a dozen aimless young men, then you could afford to neglect it. *Blast* has not been neglected. *Blast* has been greatly reviled; that is natural. Michael Agnolo fled from Pisa to escape the daggers of the artists who feared his competition. *Blast* has behind it some of the best brains in England, a set of artists who know quite well what they want. It is therefore significant. The large type and the flaring cover are merely bright plumage. They are the gay petals which lure.

*We have again arrived at an age when men can consider a statue as a statue. The hard stone is not the live coney. Its beauty cannot be the same beauty**

Art is a matter of capitals. I dare say there are still people, even in London, who have not arisen to the charm of the Egyptian and Assyrian galleries of the British Museum. If our detractors are going to talk about art in terms of " Pears Soap's Annual," and of the Royal Academy, one dismisses the matter. If they are men of goodwill, considering art in the terms of the world's masterwork, then we say simply : What is the charm in Assurbanipal's hunting? What is the charm in Isis with the young Horus between her knees and the green stone wings drawn tight about them? What is the æsthetic-dynamic basis for our enjoyment of these various periods? What are the means

* This passage was not italicized in the first printing of this article.

at the artist's disposal? What quality have the bronzes of Shang?

And when they have answered these questions there is no longer any quarrel between us. There are questions of taste and of preference, but no dispute about art. So that we find the " men of traditions " in agreement or in sympathy. We find the men of no traditions, or of provincial traditions, against us. We find the unthinking against us. We find the men whose minds have petrified at forty, or at fifty, or at twenty, most resolutely against us.

This petrifaction of the mind is one of the most curious phenomena that I have found in England. I am far from believing it to be peculiarly or exclusively English, but I have lived mostly in England since I began to take note of it. Before that I remember an American lawyer, a man of thirty, who had had typhoid and a long nervous illness. He was complaining that his mind " no longer took in things." It had lost its ability to open and grasp. He was fighting against this debility. In his case it was a matter of strength. With the second type it is, perhaps, a matter of will. This second type I have noticed mostly in England, but I think it would be the same from Portugal to Siberia. This type of mind shuts, at eighteen, or at five and twenty, or at thirty or forty. The age of the closure varies but the effect is the same. You find a man one week young, interested, active, following your thought with his thought, parrying and countering, so that the thought you have between you is more alive than the thought you may have apart. And the next week (it is almost as sudden as that) he is senile. He is anchored to a dozen set phrases. He will deny a new thought about art. He will deny the potentialities of a new scientific discovery, without weighing either. You look sadly back over the gulf, as Ut Napishtim looked back at the shades of the dead, the live man is no longer with you. And then, like as not, some further process sets in. It is the sadisme of the intellect, it is blight of Tertullian. The man becomes not only a detester but a persecutor of living and unfolding ideas. He not only refuses them, but he wishes to prevent you from having them. He has gone from Elysium into the *basso inferno*. The speed of light, the absolute power of the planes in Egyptian

sculpture have no charm left for such men. And the living move on without them.

So much for opponents. As for Brzeska's work itself : what more can I say of it? That I like it; that I believe in it; that I have lived with it; that its " definition of masses " seems to me expressive of emotional and intellectual forces; that I have bought such fragments as my limited means afford; that a man with Brzeska's skill could easily have a house in Park Lane and a seat in the Academy if he chose to make the pretty-pretties which the pink-satined bourgeosie desire. (The sequence is easy : you make for the market, you become rich; being rich, you are irresistible, honours are showered upon you.)

And it happens, this sculptor, instead of making pretty-pretties, chooses to make works of art. There are always two parties in " civilization." There is the party which believes that the stability of property is the end and the all. There are those who believe that the aim of civilization is to keep alive the creative, the intellectually-inventive-creative spirit and ability in man— and that a reasonable stability of property may be perhaps one of the many means to this end, or that it may not be detrimental, or even that it doesn't much matter. Because of this indiffer-ence to the stability of life and property on the part of one segment, this entire party is branded anarchic, or incendiary. " New art " is thought dangerous, and the dangerous is branded as " ugly." Those who fear the new art also hate it.

I had, for a long time, a " most hideous " Brzeska statue where the morning light came on it as it woke me, and because of this shifting light plane after plane, outline after expressive outline was given me day after day, emphasised, taken apart from the rest. This was a statue which I had chosen when I had but glanced at it and not fully taken it in. I cannot impose further tests. The beauty was first there in the mass. It was secondly there in the detail, which I now know thoroughly, and not merely as one knows a thing seen in the hurry of some exhibition. A man having this ability to make beauty which endures months of study and which does not decrease as you learn it more inti-mately, is what we call a great artist.

You, gracious reader, may be a charming woman who only like pretty men, a statue of a primitive man holding a rabbit

may not be a matter of interest to you, but that is no reason for abusing the artist. Or, on the other hand, ferocious and intolerant reader, you may be a vigorous male, who likes nothing save pretty women, and who despises feminine opinions about the arts. In either case you are quite right in saying that you dislike the new sculpture, you are being no more than honest. But there is no cause for calling it unenjoyable or even ugly, if you do you are but stupid, you hate the labour of beginning to understand a new form. As for me, I have no objection to " art as an Aphrodisiac," but there are other possible motifs.

And the " new form." What is it? It is what we have said. It is an arrangement of masses in relation. It is not an empty copy of empty Roman allegories that are themselves copies of copies. It is not a mimicry of external life. It is energy cut into stone, making the stone expressive in its fit and particular manner. It has regard to the stone. It is not something suitable for plaster or bronze, transferred to stone by machines and underlings. It regards the nature of the medium, of both the tools and the matter. These are its conventions and limits.

And if the Germans succeed in damaging Gaudier-Brzeska they will have done more harm to art than they have by the destruction of Rheims Cathedral, for a building once made and recorded can, with some care, be remade, but the uncreated forms of a man of genius cannot be set forth by another.

It may not be out of place to quote still another article, " Analysis of the Decade," not merely because Brzeska is mentioned in it, but because I think any consideration of vorticist art is incomplete if it does not make some mention of a sense of awakening and of our belief in the present.

" Will and consciousness are our Vortex," and an integral part of that consciousness is the unwavering feeling that we live in a time as active and as significant as the Cinquecento. We feel this ingress and we are full of the will for its expression.

AFFIRMATIONS*

ANALYSIS OF THIS DECADE

THE Renaissance is a convenient stalking-horse for all young men with ideas. You can prove anything you like by the Renaissance; yet, for all that, there seems to be something in the study of the quattrocento which communicates vigour to the student of it, especially to such scholars as have considered the whole age, the composite life of the age, in contradistinction to those who have sentimentalized over its æsthetics. Burckhardt writes in German with the verve of the best French heavy prose. Villari's Italian is thoroughly Germanized; he writes always with an eye on modern national development for Italy, he has presumably an atrocious taste in pictures, he is out of sympathy with many of the Renaissance enthusiasms, and yet manages to be interesting and most shrewd in his critical estimates, even of things he dislikes (*e.g.*, though he speaks with reverence of Raphael, he sees quite clearly the inferiority of Renaissance painting to the painting which went before, and attributes it to the right lack of energy).

Whatever one's party, the Renaissance is perhaps the only period in history that can be of much use to one—for the adducing of pious examples, and for showing " horrible results." It may be an hallucination, but one seems able to find modern civilization in its simple elements in the Renaissance. The motive ideas were not then confused and mingled into so many fine shades and combinations one with the other.

Never was the life of arts so obviously and conspicuously intermingled with the life of power. Rightly or wrongly, it is looked back to as a sort of golden age for the arts and for the litterati, and I suppose no student, however imperfect his equipment, can ever quite rest until he has made his own analysis, or written out his own book or essay. I shall not do that here; I shall only draw up a brief table of forces : first, those which seem to me to have been the effective propaganda of the Renaissance;

* *New Age,* February 11th, 1915.

secondly, those which seem to me the acting ideas of this decade —not that they are exclusively of this decade, but it seems that they have, in this decade, come in a curious way into focus, and have become at least in some degree operative. I shall identify the motive ideas in each case with the men who may, roughly, be considered as their incarnations or exponents.

The Renaissance, as you have all read forty times, was " caused " by the invention of printing and the consequently increased rapidity in the multiplication of books, by the fall of Constantinople (which happened after the Renaissance was somewhat well under way, granting that it—the Renaissance— had not been more or less under way since the fall of Rome). Let us say, however, that various causes worked together and caused, or assisted or accelerated, a complex result. The fall of Constantinople made necessary new trade routes, drove Columbus into the West Indies, sent Crisolora to Florence with a knowledge of Greek, and Filelfo to Milan with a bad temper. And these things synchronized with " the revival of classicism," and just preceded the shaping up of mediæval Europe into more or less the modern " great States."

This " revival of classicism," a very vague phrase, is analysable, at the start, into a few very different men, and each one had a very definite propaganda.

Ficino was seized in his youth by Cosimo dei Medici and set to work translating a Greek that was in spirit anything but " classic." That is to say, you had, ultimately, a " Platonic " academy messing up Christian and Pagan mysticism, allegory, occultism, demonology, Trismegistus, Psellus, Porphyry, into a most eloquent and exciting and exhilarating hotch-potch, which " did for " the mediæval fear of the *dies iræ* and for human abasement generally. Ficino himself writes of Hermes Trismegistus in a New Testament Latin, and arranges his chronology by co-dating Hermes' great-grandfather with Moses.

Somewhat later Pico writes his " De Dignitate " in endless periods, among which is one so eloquent that it is being continually quoted.

Pico della Mirandola based his own propaganda on what we should call a very simple and obvious proposition. He claimed that science and knowledge generally were not, or, at least,

should not, or need not be, grounded solely and exclusively on the knowledge of the Greeks and Romans. This created horrible scandal. People had indeed heard of Arabs and Hebrews, but this scoundrelly Pico insisted that there were still other languages and unexplored traditions. It was very inconvenient to hear that one was not omniscient. It still is. It was equally bad when Erasmus wanted scholars to begin using accent-marks over Greek letters. I sympathize with the scholars who objected to being bothered with " Tittle-tattles."

The finest force of the age, I think, came early—came from Lorenzo Valla. He had a great passion for exactness, and he valued the Roman vortex. By philology, by the "harmless" study of language, he dissipated the donation of Constantine. The revival of Roman Law, while not his private act, was made possible or accelerated by him. His dictum that eloquence and dialectic were one—i.e., that good sense is the backbone of eloquence—is still worth considering. I suppose anyone will now admit it in theory. Also, he taught the world once more how to write Latin, which was perhaps valuable. Seeing that they were drawing much of their thought from Latin sources, a lively familiarity with that tongue could not but clarify their impressions.

At this time, also, observation came back into vogue, stimulated, some say, by a reading of classics. The thing that mattered was a revival of the sense of realism : the substitution of Homer for Virgil; the attitude of Odysseus for that of the snivelling Æneas (who was probably not so bad as Virgil makes out).

As Valla had come to exactness, it was possible for Machiavelli to write with clarity. I do not wish to become entoiled in the political phases save in so far as they are inextricably bound in with literature. Tyranny, democracy, etc., these things were, in the quattrocento and cinquecento, debatable ideas, transient facts. None of them could be taken for granted. In Machiavelli's prose we have a realism born perhaps from Valla's exactness and the realism of Homer, both coming to Machiavelli indirectly.

And in the midst of these awakenings Italy went to rot, destroyed by rhetoric, destroyed by the periodic sentence and by the flowing paragraph, as the Roman Empire had been

destroyed before her. For when words cease to cling close to things, kingdoms fall, empires wane and diminish. Rome went because it was no longer the fashion to hit the nail on the head. They desired orators. And, curiously enough, in the mid-Renaissance, rhetoric and floridity were drawn out of the very Greek and Latin revival that had freed the world from mediævalism and Aquinas.

Quintilian " did for " the direct sentence. And the Greek language was made an excuse for more adjectives. I know no place where this can be more readily seen than in the Hymns to the Gods appended to Divus' translation of the Odyssey into Latin. The attempt to reproduce Greek by Latin produced a new dialect that was never spoken and had never before been read. The rhetoric got into painting. The habit of having no definite conviction save that it was glorious to reflect life in a given determined costume or decoration " did for " the painters.

Our thought jumps from the Renaissance to the present because it is only recently that men have begun to combat the Renaissance. I do not mean that they merely react against it; that was done in the hideous and deadening counter-reformation; but we have begun deliberately to try to free ourselves from the Renaissance shackles, as the Renaissance freed itself from the Middle Ages.

We may regard all the intervening movements as revivals of the Renaissance or as continuations of special phases: for instance, the various forms of " classicism " getting " colder and colder," or more and more florid. Rousseau was almost born out of his due time, and Napoleon is but an exaggerated condottiero to the very detail of the Roman robe in which he surmounts the column Vendôme. It would be quite possible to sustain the thesis that we are still a continuation of certain Renaissance phases, that we still follow one or two dicta of Pico or Valla. But we have in so many ways made definite a divergence (not a volte-face, because we are scarcely returning to pious Catholicism or to limited mediævalism). It is easier, it is clearer, to call this age a new focus. By focus I do not in the least mean that the forces focussed are in themselves new inventions. I mean that they begin to act. I mean, also, that the results are decidedly different from the results of Renaissance theory

114

and æsthetics. It is not long since Springer wrote: "Durch
Raffael ist das Madonnenideal Fleisch geworden." We remove
ourselves from the state of mind of Herr Springer.

A certain number of fairly simple and now obvious ideas
moved the Renaissance; their ramifications and interactions are
still a force with the people. A certain number of simple and
obvious ideas running together and interacting, are making a
new, and to many a most obnoxious, art. I need scarcely say
that there were many people to whom the art of the quattro-
cento and the paganism of the Renaissance seemed equally
damnnable, unimportant, obnoxious. It was "Rome or
Geneva." I shall give these simple ideas of this decade as
directly as I have given the ideas which seem to me to be the
motifs of the Renaissance. I shall give the names of men who
embody them. I shall make some few explanations and no
apology whatsoever.

Ford Hueffer, a sense of the *mot juste*. The belief that poetry
should be at least as well written as prose, and that "good prose
is just your conversation."

This is out of Flaubert and Turgenev and Stendhal, and
what you will. It is not invention, but focus. I know quite
well that Wordsworth talked about " common words," and that
Leigh Hunt wrote to Byron advising him against clichés. But
it did not deter Byron from clichés. The common word is not
the same thing as *mot juste,* not by a long way. And it is
possible to write in a stilted and bookish dialect without using
clichés. When I say the idea " becomes operative " here I pre-
sumably mean that Mr. Hueffer is the first man who has made
enemies by insisting on these ideas in England. That matter
can be discussed, and it will aid to the clarity of the discussion
if we discuss it quite apart from your opinion or my opinion of
Mr. Hueffer's work " as a whole " or in detail.

Myself, an active sense not merely of comparative literature,
but of the need for a uniform criticism of excellence based on
world-poetry, and not of the fashion of any one particular
decade of English verse, or even on English verse as a whole.
The qualitative analysis in literature (practised but never formu-
lated by Gaston Paris, Reinach in his Manual of Classical Philo-
logy, etc.). The Image.

Wyndham Lewis, a great faculty of design, synthesis of modern art movements, the sense of emotion in abstract design. A sense of the import of design not bounded by Continental achievement. A sense of dynamics.

Barzun's question: Pourquoi doubler l'image?

Gaudier-Brzeska. In him the "new" sculptural principle becomes articulate. "The feeling of masses in relation." (Practised by Epstein and countless "primitives" outside the Hellenic quasi-Renaissance tradition.) General thorough knowledge of world-sculpture. Sense of a standard not limited by 1870 or 1905.

Edward Wadsworth, sense of the need of "radicals in design," an attempt towards radicals in design. A feeling for ports and machines (most certainly not peculiar to himself, but I think a very natural and personal tendency, unstimulated in his case by Continental propaganda).

I consider this one of the age-tendencies, springing up naturally in many places and coming into the arts quite naturally and spontaneously in England, in America, and in Italy. We all know the small boy's delight in machines. It is a natural delight in a beauty that had not been pointed out by professional æsthetes. I remember young men with no care for æsthetics who certainly would not know what the devil this article was about, I remember them examining machinery catalogues, to my intense bewilderment, commenting on machines that certainly they would never own and that could never by any flight of fancy be of the least use to them. This enjoyment of machinery is just as natural and just as significant a phase of this age as was the Renaissance "enjoyment of nature for its own sake," and not merely as an illustration of dogmatic ideas. The modern sense of the value of the "creative, constructive individual" (vide Allan Upward's constant propaganda, etc., etc.) is just as definite a doctrine as the Renaissance attitude "De Dignitate," Humanism. As for external stimulus, new discoveries, new lands, new languages gradually opened to us; we have great advantage over the quattro- or cinque-cento.

Ernest Fenollosa's finds in China and Japan, his intimate personal knowledge, are no less potent than Crisolora's manuscripts. China is no less stimulating than Greece, even if Fenol-

116

losa had not had insight. And this force of external stimuli is certainly not limited by " what we do "; these new masses of unexplored arts and facts are pouring into the vortex of London. They cannot help bringing about changes as great as the Renaissance changes, even if we set ourselves blindly against it. As it is, there is life in the fusion. The complete man must have more interest in things which are in seed and dynamic than in things which are dead, dying, static.

The interest and perhaps a good deal of the force of the group I mention lie in the fact that they have perfectly definite intentions; that they are, if you like, " arrogant " enough to dare to intend " to wake the dead " (quite as definitely as did Cyriac of Ancona), that they dare to put forward specifications for a new art, quite as distinct as that of the Renaissance, and that they do not believe it impossible to achieve these results.

Many parallels will rise in the mind of the reader; I have only attempted certain obscure ones. The external forces of the Renaissance have been so often presented that one need not expatiate upon them. Certain inner causes are much less familiar, for which reason it has seemed worth while to underline the " simple directions " of Pico and Crisolora and Valla, and the good and evil of Greek. The Renaissance sought a realism and attained it. It rose in a search for precision and declined through rhetoric and rhetorical thinking, through a habit of defining things always " in terms of something else."

Whatever force there may be in our own decade and vortex is likewise in a search for a certain precision; in a refusal to define things in the terms of something else; in the " primary pigment." The Renaissance sought for a lost reality, a lost freedom. We seek for a lost reality and a lost intensity. We believe that the Renaissance was in part the result of a programme. We believe in the value of a programme in contradistinction to, but not in contradiction of, the individual impulse. Without such vagrant impulse there is no art, and the impulse is not subject to programme. The use and the limitation of force need not bring about mental confusion. An engine is not a confusion merely because it uses the force of steam and the physical principles of the lever and piston.

XIII

THERE are few things more difficult than to appraise the work of a man suddenly dead in his youth; to disentangle " promise " from achievement; to save him from that sentimentalizing which confuses the tragedy of the interruption with the merit of the work actually performed; and on the other hand to steer clear of unfair comparisons with men dead at the end of long life. To blame Raphael that he was not either Leonardo or Buonarroti would be thoroughly stupid.

Again, all writing *about* art is apt to be stupid, and one would be fairly content to present the public with no more than a portfolio of photographs were it not that one is constantly greeted with articles on " The New Spirit in Sculpture," " Modern Art," " The New Spirit in Art," etc., and that these articles invariably contain reproductions of the same set of stout young ladies in the same creased night-shirts, bearing the same set of globes, palm-branches, balances, etc., etc., etc., in the same silly positions, with the same pure, passionless insipid expressions of countenance. They are, it is true, occasionally diversified and embellished by other figures carrying hammers, crucibles, etc., wearing the same wideish trousers, the same braces, shirts, etc., loose at the neck, etc., etc., etc. No sense of form, no sense of the properties of the medium, etc., etc. ! !

How far it is permissible to stand against the waves of circumfluent idiocy I do not know.

> " I withstood the savages of the Niger with a revolver:
> I withstood the savages of the Thames with a printing press : "

says Allen Upward in a very pleasant little poem. I sit here taking pleasure in the comfortable curves of " Jojo's " fat alabaster back and I see very little necessity for writing anything. I ride from my door to Charing Cross past an indefinite number of horrors: the " Memorial," the " War Exhibit " in polychrome, that beastly statue of General X . . ., those figures in Piccadilly, that new outrage further down with the stone balances all out of balance, and it seems as if posterity might be spared these things, it seems as if the present generation

might be spared any more of these things. It seems that even violent propagandist literature might be justified if it could defend us from this daily waste and annoyance.

It seems to me that if one could persuade a few more people, the right people, to think a little about sculpture one might even give as much pleasure as one would by writing a fine lyric, even supposing the two actions excluded each other, which they do not. I do not believe that a man's critical activities interrupt his creative activities in the least. As to writing criticism, it is not a question of effort. It is merely a question of whether or no a man writes down what he thinks.

Again : there is a vast difference between writing *about* works of art, and trying to determine artistic principles.

And still again : an artistic principle, even a " formula " is not a circumscription. These " dogmas " are not limits, not signs saying " thus far and no further," but points of departure, and lines along which the thought or the work may advance.

No one can or does " create to a formula," by which phrase people mean " building out a work of art in accordance with a theory without waiting for the creative impulse." No work of value is done that way. On the other hand, a man's antecedent reflection, cogitation, etc., is bound to affect his later expression.

England has always loved the man incapable of thought, the praise of Shakespeare which they most love is some absolutely inaccurate rubbish about " wood notes wild " uttered by one of the most unpleasant of theorists. They will pardon reams of in- sipidity rather than one clear thought. I don't know that it matters, but one may as well register the fact for the comfort of future sufferers. Hence the fury which greets any " new form of art," new forms of art which are valid being always a product of thought, a double emphasis on some fundamental principle of strength or of a beauty cast aside, or rather buried under the slow accretions of stupidity, carelessness, lack of intensity.

Our battle began with Whistler, the delicate, classical " Master." I believe the Cerberi of the " Tate " still consider pre-raphaelitism a violent and dangerous innovation, but we will leave that old war out of the question.

Whistler was the only man working in England in the " Eighties " who would have known what we are at and would

119

have backed us against the mob. I do not mean to say there would have been absolute agreement, but he would not have sided with the mob, he would not have uttered " bêtises."

It is to be remembered that the " Portrait of his Mother," as it is now called, was originally exhibited as " Arrangement in Grey and Black."

(Parenthesis : I know that most of his dicta apply more immediately to vorticist painting than to Brzeska's sculpture, but they do apply to that sculpture also, and moreover my own thought about the two arts is so interwoven that it is very hard for me to write about one without amplifying some side-thought concerning the other.)

We return again and again to Pater's " All arts approach the conditions of music," and in Whistler's " Gentle Art " we find sentence after sentence full of matter—

" Art should be independent of all claptrap, should stand alone and appeal to the artistic sense of eye or ear without confounding this with emotions entirely foreign to it."

" The imitator is a poor kind of creature. If the man who paints only the tree, or flower, or other surface he sees before him were an artist, the king of artists would be the photographer. It is for the artist to do something beyond this in portrait painting, to put on canvas something more than the face the model wears for that day; to paint the man, in short, as well as his features; in arrangement of colours to treat a flower *as his key, not as his model.*"

I quote that paragraph *in toto* because it is not absolutely in accord with the vorticist aim, but it " gives to think." The last italicized words are to me the most important. True we have brought in new keys, and new, perhaps harsher, arrangements.

Applying this same principle to arrangement of planes we get the new sculpture. I am aware that most people cannot feel form " musically." That they get no joy, no thrill from an arrangement of planes. That they have no sense of form. I mean the form of things, as distinct from composition of a picture or of a statue. . . . God knows the sense of composition is appallingly deficient, especially in contemporary artists.

The pine-tree in mist upon the far hill looks like a fragment of Japanese armour.

The beauty of this pine-tree in the mist is not caused by its resemblance to the plates of the armour.

The armour, if it be beautiful at all, is not beautiful *because* of its resemblance to the pine in the mist.

In either case the beauty, in so far as it is beauty of form, is the result of " planes in relation."

The tree and the armour are beautiful because their diverse planes overlie in a certain manner.

There is the sculptor's or the painter's *key*. The presentation of this beauty is primarily his job. And the " poet "? " Pourquoi doubler l'image? " asks Barzun in declaiming against this " poésie farcie de ' comme.' " The poet, whatever his " figure of speech," will not arrive by doubling or confusing an image.

Still the artist, working in words only, may cast on the reader's mind a more vivid image of either the armour or the pine by mentioning them close together or by using some device of simile or metaphor, that is a legitimate procedure of his art, for he works not with planes or with colours but with the names of objects and of properties. It is his business so to use, so to arrange, these names as to cast a more definite image than the layman can cast; in like manner it is the painter's or the sculptor's business so to use his planes, his colours, his arrangements that they shall cast a more vivid, a more precise image of beauty upon the mind of his spectator, than the spectator can get of himself or from a so different department of art.

This is the common ground of the arts, this combat of arrangement or " harmony." The musician, the writer, the sculptor, the higher mathematician have here their common sanctuary.

It does *not* mean that the poet is to describe post-impressionist pictures, or that the sculptor is to carve allegorical figures of the dramatist's protagonists.

In different media, which are at once the simplest and the most complex, each artist works out the same and yet a totally different set of problems. And he uses the medium for which the combination of his talents most fits him.

His " agreement with fellow artists " is in many senses a matter of no importance. I mean if he has the sense of *this* common ground.

My brother artist may, and probably does, disagree with me violently on all questions of morals, philosophy, religion, politics, economics; we are indissolubly united against all non-artists and half-artists by our sense of this fundamental community, this unending adventure towards " arrangement," this search for the equations of eternity. A search which may end in results as diverse as the portrait of Miss Alexander, at her rather disagreeable age of thirteen or thereabouts, or a formula like

$$(x - a)^2 + (y - b)^2 = r^2,$$

or Brzeska's last figure of a woman, or Lewis' " Timon " or even a handful of sapphics. And I find this sort of, to me, very clear statement is often incomprehensible to people who do nothing. I mean people who merely carry on a business, or parrot out phrases in " teaching," or live respectable lives. However, I have never yet found a good artist or a good mathematician, or in fact a man whose life showed any sort of efficiency who could not grasp it at once.

Our community is no longer divided into " bohème " and " bourgeois." We have our segregation amid the men who invent and create, whether it be a discovery of unknown rivers, a solution of engineering, a composition in form, or what you will.

These men stand on one side, and the amorphous and petrified and the copying, stand on the other.

Perhaps the finest thing said of Whistler is to be found in an essay by Symons : " And in none of these things does he try to follow a fine model or try to avoid following a model."

It is for the rest an essay which contains some sense and some nonsense, the nonsense being chiefly the sort of nonsense against which Whistler had expressly inveighed.

I had intended to quote further from the " Ten O'Clock," and also from Binyon's " Flight of the Dragon," but it is perhaps enough to remind the reader that these essays exist, and one may by thinking them over, arrive at some degree of enlightenment.

Whistler was the great grammarian of the arts and one should not confuse the particular form of his expression, *i.e.* the peculiarity or the individuality of his expression of himself and his

temperament, with the principles he uttered, or with the form or art whereby some of those principles will become apparent when they apply in the expression of some one else's temperament or individuality.

XIV

THERE is another phase of " the revolt " as they call it, which is also traceable to Whistler. I mean to say " art for the intelligent."

We are, I think, getting sick of the glorification of energetic stupidity. Vienna, Mestrovic, etc., etc. (there are worse forms). The art of the stupid, by the stupid, for the stupid is not all-sufficient. Whistler was almost the first man, at least the first painter of the last century to suggest that intelligent and not wholly ignorant and uncultivated men had a right to art. Their art is always opposed and always triumphant. Of this art was Gaudier-Brzeska, in this sense he was " of the movement." By " the movement " I mean something wider than the association of certain artists a year or so since in Ormond Street.

After an intolerable generation we find again this awakening, not in one spot but in several. Lewis, Brzeska, James Joyce, T. S. Eliot all proving independently and sporadically that the possession of a certain measure of intellect, education, enlightenment does not absolutely unfit a man for artistic composition.

In this awakening I find very great comfort.

XV

AGAIN: it is difficult to stop writing. One stands the racket of what is called the " revolt." Any action of the intelligence is of course a " revolt " against the dough-like properties and propensities of the race. There would be no need of " revolt " if things said were also things thought over by hearers. So one is destined to reiterations, and turns again to the " Ten O'Clock."

" Nature contains the elements." It is to be noted that one is not forbidden any element, any key because it is geological rather than vegetable, or because it belongs to the realm of magnetic currents or to the binding properties of steel girders and not to the flopping of grass or the contours of the parochial churchyard.

" The artist is born to pick and choose, and *group with science*, these elements, that the result may be beautiful—as the musician gathers his notes and forms his chords."

There, again, is a basis. One uses form as a musician uses sound. One does not imitate the wood dove, or at least one does not confine oneself to the imitation of wood-doves, one combines and arranges one's sound or one's forms into Bach fugues or into arrangements of colour, or into " planes in relation."

XVI

ROUGHLY: What have they done for me these vorticist artists?

They have awakened my sense of form, or they " have given me a new sense of form," or what you will. I remember a time, it was in the provinces and therefore not so long ago as it would have been in London, when Oriental art was new and strange (yes, I know China was heard of in the eighteenth century, but she was laid aside and forgotten), a time when Chinese painting was ill received, and I still meet people who say all Japanese prints look alike.

I remember when impressionism, *i.e.* the work of Manet and Monet and their followers awakened a sense of colour, or a sense of light, and we began to see purple shadows instead of black shadows or whatever they had been supposed to be, at any rate we were resensitized to colour. I have talked with men who " hadn't got as far as these painters."

I have heard Mr. —— telling how his father's technique was of an earlier school, and that the Impressionist technique invalidated it, and his father's work never caught up.

" Whistler set people to seeing the beauty of fogs and the night on the Thames," etc.

These new men have made me see form, have made me more conscious of the appearance of the sky where it juts down between houses, of the bright pattern of sunlight which the bath water throws up on the ceiling, of the great " V's " of light that dart through the chinks over the curtain rings, all these are new chords, new keys of design.

And my eye is ten times as quick to discriminate between fine and mediocre Chinese or Japanese prints or paintings.

All this is new life, it gives a new aroma, a new keenness for keeping awake. The swirls in the film on my morning coffee I had watched for some years. They make Whistlerian butter-flies, they are in a known key, *experimenté*. This new awakening to form may be a purely personal matter. Certain decorative artists may always have had it . . . and yet . . . and yet they

have done very little to make us aware of it. They may have needed it, they may not have been able to make their designs and their pictures without it . . . yet they have found very few new combinations. They have not communicated it.

If vorticism has done this for me, I think it can do it for others. Others?

Of course the rest of the world may not want a new sense of forms, or a new sense of anything.

I think it is De Quincey who writes of " the miracle that can be wrought if only one man feels a thing more keenly, knows it more intimately than any one has known or felt it before." Such a miracle has been performed in our vicinity.

I dare say various miracles have been so wrought for the few. I am constantly surprised at the faintness of men's talent for living, at the number of things they so willingly do without. The people who lived without Gaudier's sculpture . . . perhaps that was through ignorance. The people who live without Dolmetsch's instruments . . . that cannot be ignorance . . . but still it is all one tendency.

" I have not repulsed God in his manifestations," says the old Egyptian poet. To-day I see so many who could not say, or who could scarcely say it, for these manifestations at their intensest are the manifestations of men in the heat of their art, of men making instruments, for the best art is perhaps only the making of instruments.

A clavicord or a statue or a poem, wrought out of ages of knowledge, out of fine perception and skill, that some other man, that a hundred other men, in moments of weariness can wake beautiful sound with little effort, that they can be carried out of the realm of annoyance into the calm realm of truth, into the world unchanging, the world of fine animal life, the world of pure form. And John Heydon, long before our present day theorists, had written of the joys of pure form . . . inorganic, geometrical form, in his " Holy Guide."

All these thoughts gather around one, in one's thought of this new painting and sculpture. . . . And around its detractors, what thoughts?

I think there must be around them very little thought or they would not oppose it.

XVII

Partial Catalogue of the Sculpture

It is perhaps desirable to give a catalogue *raisonné* of Gaudier's later work. I cannot be sure of completeness, but there are extant the following authentic works. I give the approximate time of their creation, though I cannot swear to it.

1. Marble group, man and woman, Taihitian (?). At least one might so regard its ancestry were it not one of Gaudier's most personal expressions. The faces do, I think, suggest some Oceanic tradition, the right arm of the woman is most delicate in its straightness, and suggests that of a certain Isis with Horus between her knees (green stone, British Museum). (In possession of the author.)

2. Angel, with Dantescan face, huge breasts, done in alabaster, robe painted vivid scarlet. A scandalous satire.

3. Chanteuse Triste, grey stone, earlier period. Convention possibly archaic Greek, woman singing, arms crossed behind her.

4. Boy in alabaster (possession of Omega workshops), fat boy with arm held above his head, elbow sharply squared, à la Picasso.

There were also 5 a "head of Christ," and 6 an "Infant Hercules" in grey stone, of period of Chanteuse. The Hercules was broken in moving to the Putney studio, but its head may survive.

7. Naturalistic torse marble, destined for South Kensington, described before.

8. Another torse, marble, plumper, not so strong. (Possession of Mrs. H. H. Shakespear.)

9. Vase, or Water Carrier. Interesting, a nondescript animal. soft marble, supporting a cup made of different stone. Reproduced. (John Quinn.)

10. Bas Relief of a Cat. Reproduced. (John Quinn.)

11. A bas relief of a fattish woman with squarish man creeping toward her. Unimportant.

12. Very fine bas relief of a woman, on small marble pyx presented to Wilfrid Scawen Blunt.

13. Bust of Ezra Pound, sufficiently described in text. Works in brown veined alabaster: All important.

14. The Stags, reproduced.

15. Boy with a Coney, reproduced, described by Brzeska in his review of the " Allied Artists."

16. Seated Figure. I think this was his last or almost his last work.

These three show that " soft bluntness " and are the most original, most exclusively his own creation, and owe less to any possible " influence " from outside himself.

17. " Bird swallowing a fish," belongs more or less to this group and is an expression of the same train of research.

18, 19, and 20. Cut brass: two door-knockers, and " toy " for Mr. Hulme. The " toy " being the first experiment and the best of the three.

21. Paperweight. In alabaster. (In possession of G. Hyde-Lees.) Reproductions of the same in brass, cast.

22. A green stone charm.

23. Small faun in brown stone.

24. Earlier. A Faun, crouching, sold at Alpine Club Show several years ago. Reproduced.

Earlier still, some naturalistic busts, more or less à la Rodin.

25. Tiny brass fish, for Mrs. Kibblewhite.

26. Model of cat for porcelain. (Omega shops.)

There was an earlier period when he did figures with bunchy muscles. I do not know whether they survive. Also, I think he used to buy cheap figures and transform them, at some obscure period.

27. The Dancer, brown stone, varnished. Reproduced; very fine.

28. Imp, late work, grotesque. Reproduced.

29. Caritas, grey stone, date uncertain, possibly about the time of the stags. Woman giving suck to two children, abstract top.

30. Boy, in plaster. Omega shops, unimportant.

31. Chubby figure with bowed head, alabaster, early, unimportant.
32. A large bas relief of wrestlers.
33. Woman seated, grey stone, same period as Chanteuse, reproduced in *Egoist,* Feb. 16th, 1914.
34. Boy in alabaster, high relief against gilt background, early. (In possession of Mr. Kohnstam.)
35. Birds Erect. This is one of the most important pieces. The representative element is very slight. The work is the culmination of the study of a set of forms begun in Mr. Hulme's toy, or rather in the drawings which preceded that work in cut brass. These forms are in some degree related to the series of forms used in the " Bird swallowing a fish," but they are distinctly different. As a composition of masses I do not think I have seen any modern sculpture to match it.

XVIII

The Drawings

I SHALL not attempt a full catalogue of the drawings, or even a moderately full catalogue.

The development seems to have been as follows: Heterogeneous period before 1912. Pastel, etchings, etc., 1912. Drawings done in full influence of the theory that painting, or at least drawing, "is caligraphy." To this period belong the drawing of Brodsky's head. Small drawing of stag in Brodsky's possession.

The three large pages of stags seem to be from the end of this period and one notices the effect of the widening pen-strokes.

1913 roughly speaking seems to have been the year for the drawings, of nudes and animals, in the thin even line, vide the wolf, woman (plates II, VII).

The animal drawings with thicker line seem to have been done, for the most part, about the end of 1912, just before the nudes in thin line, but I do not wish to be too definite about these dates.

At the end of 1913 came almost the final phase, vide the man on horseback (plate VII). In these two drawings we see the accumulated skill due to the former diligence. The man on the horse has the certitude and the manner which I at least must relate in my own mind and for the convenience of reference to the animals of the Chou dynasty.

The stags, and the animals done in their manner, were, I should think, done while he was enthused by the drawings in the Dordogne caverns and "Fonts-de-Gaume."

Of the later thick line suave drawings I have seen only a few. One is a family, man, woman, and infant, the feeling is relatable, or at least the general disposition of the subject is not unlike Van Gogh and I have therefore chosen to reproduce the less familiar and more individual compositions.

The relations of these later drawings, especially the equestrian,

131

the straight fingers, heavy shoulders—to the sculpture of the same phase, like the dancer, is easily visible.

The drawing of the man and women has rapport with a plaster figure of the same date, but the drawing is the better piece of work.

The drawing seen in the background of the photograph of Gaudier standing by his " Bird swallowing a fish," is probably an early study for the dancer or else for some other statue that was not done. The importance of the " Bird swallowing a fish " is not to be under-estimated, though the subject is scarcely popular in its appeal.

The squarish female figure in the photograph (plate XXVII) is, I think, the last work that Brzeska completed before his departure for France.

Again I feel that I cannot over-emphasize the fact that this squarish, bluntish figure was his last work in stone. This and the " Boy with a Coney," and the " Imp " and the " Dancer," and " Bird swallowing a fish," are all of a unity. They are all in a peculiar sense *his* work, free from influence, the personal style which is even by great artists often attained only toward the end of a lifetime.

The embracing figures are a very personal expression. No one but Gaudier could have made them, but they are full of reminiscence, Oceanic, Egyptian. In the work of young genius we see often the passion of the artist fusing such derived elements into a single work. That work is work of promise. The other work, in the present case, the bluntish and squarish, is not work of promise but work of achievement.

The seated figures and, emphatically and particularly, the man on horseback in the drawing bear the same relation to the earlier phases of his drawing. You will not find anyone to improve on the earlier drawings of stags, but still the Fonts-de Gaume exist for comparison. Gaudier's work is, I suppose, as good as the cave drawings, but they were his " pace-maker."

The later work came from himself, at least it was his final decision.

Speaking meticulously, two pencil drawings done in the trenches were his last work, but one cannot compare them with

work done in the leisure of the studio. The mitrailleuse is quite good.

Anyone wishing to understand certain phases of Gaudier's thought about form should endeavour to see a large number of his drawings. A portfolio of them would be of great use to students. This statement applies as much to the heavy-lined, little notes as to the more comprehensible drawings of animals thin in line.

One finds him developing his abstractions, reducing the imitative drawing of an horse to the relative masses, or working down to the simple design of his alabaster paper-weight from a series of red "incomprehensible" skeletons of the human figure. The line drawings here reproduced lose most of their character through our necessity to represent the original sheet of paper by an illustration one fourth its size.

A full catalogue of the drawings is, I repeat, out of the question at present or in this book. The line drawings are roughly divisible into : *animals* (his drawings of the feline and lupine creatures, being perhaps the best of this lot, though the birds also are excellent), nudes, satiric drawings of people riding in the Row and of "The Social Order."

There are a few figures in heavier line in very black ink, very important drawings of the "wrestlers," and of "man standing by a horse." There are also studies for sculpture and very "modern," drawings, that is to say drawings composed almost wholly of inorganic forms.

His long meditation on the relative value of organic and inorganic forms is witnessed by the great number of studies of fishes and birds, in which creatures the division between the two, that is between organic and inorganic forms, is less obvious.

Perhaps, with the reader's indulgence, I may be permitted another brief note of emphasis or appendix anent the cut-brass work. I have reproduced the " Toy " and the small fish on plate XVI.

These experiments in abstract form interest me. It interests me that Mr. Hulme in his boyhood should have pestered the village blacksmith week in and week out to forge him a piece of metal absolutely square. The boys in my home town used, as I said in my paragraph on Wadsworth, to spend hours over catalogues of machinery. These tastes are perfectly natural and form a part of æsthetics just as much as the velleities of the pink and mauve era. The Romans had a passion for squareness. At Sirmione they have chopped off a corner of cliff in one place and built out the cliff in another simply to produce a pleasurable outline.

I refer the reader again to John Heydon's " Holy Guide " for numerous remarks on pure form and the delights thereof. And I might do worse than close with the following citations from so conservative a work as Mr. Binyon's " Flight of the Dragon." They bear on much of Gaudier's work, not merely upon the cut brass.

" Every statue, every picture, is a series of ordered relations, controlled, as the body is controlled in the dance, by the will to express a single idea.

" In a bad painting the units of form, mass, colour, are robbed of their potential energy, isolated, because brought into no organic relation.

" Art is not an adjunct to existence, a reproduction of the actual.

" FOR INDEED IT IS NOT ESSENTIAL THAT THE SUBJECT-MATTER SHOULD REPRESENT OR BE LIKE ANYTHING IN NATURE; ONLY IT MUST BE ALIVE WITH A RHYTHMIC VITALITY OF ITS OWN."

He quotes with approbation a Chinese author as follows :—As a man's language is an unerring index to his nature, so the actual

strokes of his brush in writing or painting betray him and announce either the freedom and nobility of his soul or its meanness and limitation.

"You may say that the waves of Korin's famous screen are not like real waves : but they move, they have force and volume.

"It would be vain to deny that certain kinds and tones of colour have real correspondence with emotional states of mind.

"Chemists had not multiplied colours for the painter, but he knew how to prepare those he had.

"Our thoughts about decoration are too much dominated, I think, by the conception of pattern as a sort of mosaic, each element in the pattern being repeated, a form without life of its own, something inert and bounded by itself. We get a mechanical succession which aims at rhythm, but does not attain rhythmic vitality."

E.P.

PREFACE TO THE
MEMORIAL EXHIBITION 1918 *

His death in action at Neuville St. Vaast is, to my mind, the gravest individual loss which the arts have sustained during the war. When I say this I am not forgetting that Remy de Gourmont, Henry James, and, lastly, Claude Debussy must all be counted among war losses, for in each case their lives were indubitably shortened by war-strain; but they, on the other hand, had nearly fulfilled their labour, each was still vigorously productive, but we could in fair measure guage the quality of what they were likely to do.

Gaudier was at the beginning of his work. The sculpture here shown is but a few years' chiseling. He was killed at the age of twenty-four; his work stopped a year before that. The technical proficiency in the Stag drawings must be obvious to the most hurried observer. The volume and scope of the work is, for so young a man, wholly amazing, no less in variety than in the speed of development.

In brief, his sculptural career may be traced as follows: It begins with " representative " portrait busts in plaster, and with work in more or less the manner of Rodin. Whatever one may think of Rodin, one must grant that he delivered us from the tradition of the Florentine Boy, and the back-parlour sculptural school favoured by the Luxembourg. Gaudier was quickly discontented with the vagueness and washiness of the Rodin decadence and the work of Rodin's lesser imitators. We next find him in search of a style, interested in Epstein, but much more restless and inquisitive. In " The Singer " we have what may seem an influence from archaic Greek, we have the crossed arms motif, used, however, very differently from the crossed or x'd arms of the splendid Moscophoros. (The anti-Hellenist cannot refrain from a slightly malicious chuckle on observing that the Greeks really had a great master (before Phidias), and that they have carefully forgotton his name. *Vide* also the consummate

* The Leicester Galleries, London, May–June, 1918.

inanities in the Encyclopedia Britannica regarding the Mosco-phoros). In the Singer we may observe also an elongation possibly ascribable to a temporary admiration of the Gothic.

In "The Embracers" (plate XXIV) we find a whole pot-pourri of forces: Egypt in the delicate flattening of the woman's right arm, Oceanic influence in the rest of it. Note that all great artists are imitative in their early work; their power lies in the rapidity with which they assimilate, digest, get through with, weld into a style of their own, the forces and qualities of their models. Obvious as one or two acquired qualities are in " The Em-bracers ", it is perhaps the most complete expression of Gaudier's personality that remains to us. It is also intensely original, the stylization into the bent prismatic shape of the whole does not, I think, occur elsewhere. He has shown the " sense of stone " in the utilisation of this queer-shaped block as Michelangelo showed it in the economy of his " David " (a block, as you remember, which none of his contemporaries could handle, and which was regarded as spoiled, and useless).

Gaudier denied the Chinese influence in " Boy with a Coney ", (plate XXIII), a piece more opulent in its curves than " The Embracers ", though perhaps less striking at first sight, because of its greater placidity.

By the time he got to " The Dancer " (plates XXI, XXII), Gaudier had worked definitely free from influence. This work is his own throughout. I can but call upon the unfamiliar spectator to consider what it means to have worked free of influence, to have established a personal style at the age of twenty-two. There is no minimising such achievement.

The personality is asserted in " The Embracers ", the style is established and freed from derivativeness in " The Dancer ". This last is almost a thesis of his ideas upon the use of pure form. We have the triangle and circle asserted, *labled* almost, upon the face and right breast. Into these so-called " abstractions " life flows, the circle moves and elongates into the oval, it increases and takes volume in the sphere or hemisphere of the breast. The triangle moves toward organism it becomes a spherical triangle (the central life-form common to both Brzeska and Lewis). These two developed motifs work as themes in a fugue. We have the whole series of spherical triangles, as in the arm over the head,

all combining and culminating in the great sweep of the back of the shoulders, as fine as any surface in all sculpture. The " abstract " or mathematical bareness of the triangle and circle are fully incarnate, made flesh, full of vitality and of energy. The whole form-series ends, passes into stasis with the circular base or platform.

I am not saying that every statue should be a complete thesis of principles. I simply point out the amazing fact that Gaudier should so clearly have known his own mind, that he should have been able to make so definite an assertion of his sculptural norm or main urges at the age of but two and twenty.

The quality of his stone animals, his sense of animal life seems too obvious to need note in this preface.

Because our form sense is so atrophied it is necessary to point it out, even to wrangle about it with unbelievers. Again Gaudier's technical power seems too obvious to need explanation, whether it be in cutting of brass, or in the little green charm, or in the splintery alabaster, or in the accomplished ease of the drawings.

If the " more modern pieces " puzzle the spectator there are various avenues of approach. First, by Gaudier's own manifestoes.

" *Sculptural feeling is the appreciation of masses in relation.*
Sculptural ability is the defining of these masses by planes.

Secondly, by a study of Egyptian, Assyrian, African and Chinese, sculpture, and a realisation that Hellenism, neo-Hellenism, neo-Renaissancism and Albert Memorialism do not contain and circumscribe all that it is possible to know on the subject. Only those shut in the blind alley which culminates in the Victorian period have failed to do justice to Gaudier. My praise of him is no longer regarded as an eccentricity.

He is irreplaceable. The great sculptor must combine two qualities (*a*) the sense of form (of masses in relation); (*b*) tremendous physical activeness. The critic may know fine forms when he sees them embodied, he may even be able to construct fine combinations of form in his imagination. This does not make him a sculptor.

The painter may be able to record or set forth fine form-combinations, to " knock off " a masterpiece in four hours.

The sculptor must add to the power of imagining form-

combination the physical energy required to cut this into the unyielding medium. He must have vividness of perception, he must have this untiringness, he must, beyond that, be able to retain his main idea unwaveringly during the time (weeks or months) of the carving. This needs a peculiar equipment. Easily diverted, flittering quickness of mind is small use.

When a man has all these qualities, vividness of insight, poignancy, retentiveness, plus the energy, he has chance of making permanent sculpture. Gaudier had them, even to the superfluous abundance of forging his own chisels.

For the rest, *circumspice!* I can but record the profundity of the cry that came from the Belgian poet, Marcel Wyseur, on first seeing some work of Gaudier-Brzeska's : " Il a eu grand tort de mourir, cet homme ! Il a eu grand tort de mourir ".

1918

GAUDIER : A POSTSCRIPT 1934*

For eighteen years the death of Henri Gaudier has been un-remedied. The work of two or three years remains, but the uncreated went with him.

There is no reason to pardon this either to the central powers or to the allies or to ourselves.

I dare say there was never a man better fitted to serve in trench warfare, and his contempt for war is a message. A contempt for war is by no means a contempt for physical courage.

" I seen so many better guys bumped off!" said Mr. Hemingway in the face of a minor author's obituaries. Than Henri Gaudier no better guy was bumped off.

With a hundred fat rich men working overtime to start another war or another six wars for the sake of their personal profit, it is very hard for me to write of Gaudier with the lavender tones of dispassionate reminiscence. The real trouble with war (modern war) is that it gives no one a chance to kill the right people.

William Hohenzollern was never in personal danger, the Baron de Wendel, Zaharoff, the brothers Schneider were never in personal danger, nor were the Krupp and Vickers directors. Hence the stink of the shambles. They say the ancient Serbian custom was to send the old men first into the battle. I could nominate nearly a full regiment.

The art of a period is what the artists make during that period, apart from that there are, in Foch's magnificent phrase " merely verbal manifestations."

Good sculpture does not occur in a decadence. Literature may come out of a decadence, painting may come out of a decadence, but in a decadence men do not cut stone.

A few blocks of stone really carved are very nearly sufficient base for a new civilization. The garbage of three empires collapsed over Gaudier's marble. And as that swill is cleared off, as the map of a new Europe becomes visible Gaudier's work re-emerges, perfectly solid. The last country to be seen collapsing

* *Esquire*, New York, August, 1934.

is his own. The real France of the banks and gun works shows in Stawisky. I suppose he, Stawisky, was a great minor crook and owed his immunity to his knowledge of the real ghouls and wreckers.

Having said what I knew about Gaudier in my memoir of him I should have very slight excuse for restatement unless I could now show the same facts in some other light or perspective.

An artist's statement is made in and by his work. His work is his biography, and the better the artist the more this applies. "There is my autobiography" said Jean Cocteau one day when we were expressing mutual annoyance with the series of importunates who return again and again to requesting it.

The significance of Gaudier's sculpture is now granted, so far as I know, without demur by any person of the slightest competence. In 1916 it wasn't. The work was done from 1912 to 1914, with perhaps a little preliminary skirmishing in 1911, it was done against the whole social system in the sense that it was done against poverty and the lack of materials.

All our work was the work of outlaws, and the significance of that fact is now, with the passing of two decades, effulgent.. I stated in my memoir that this fact had a meaning. I stated the meaning : Namely that the upper strata of society was rotten, I don't mean sexually fantastic, but that the whole mind of the exploiting class was trivial, idiotic, and that the best conversation was found *in quadriviis et angiportis.*

The white-gleaming intelligence in Gaudier's studio (half the space under a railway arch in Putney with the sides boarded up) in comparison with the podgy and bulbous expensiveness of Schonbrun, the tawdry, gummy, adhesive costliness of the trappings of the bourgeois drawing-rooms of the period, had a meaning.

And that meaning is now written into history. You can't keep a good man down, you can't keep the *beau monde* under, and the *beau monde* is the "world" with the most beautiful mind.

The "revolution in the arts" was quite distinctly revolution. The social revolution was coming, that is to say the most intelligent young ladies of Mayfair were spending their time in Tottenham Court Road to escape from society boredom. The young women with lesser mental equipment were seen *only* in their

hereditary surroundings.

The key word of vorticist art was Objectivity in the sense that we insisted that the value of a piece of sculpture was dependent on its shape.

It is probably difficult for the contemporary (1934) reader to conceive any other position, yet if the last snippet of newspaper concerning London speaks the truth, the ineffable Britons have recently elected a director of their National Gallery who doesn't yet know this, and whose views on painting are equally stupid.

Pre-war Europe was guttering down to its end. One tried to persuade it to make a " good end ". One may even have thought one was in the act of succeeding. In any case the years immediately before the great slaughter were full of exhilaration for those in the middle of the action—I suppose one must call it the intellectual scene—it was rather like a battle between a weasel and a cow with all the fun for the weasel. Whether we supposed we could trans-animate the cow and produce a miraculous super-antelope or springbok, I doubt. At any rate capitalist society refused to make a good end. They hadn't the theatrical élan supposed to have been present in the aristos during the French revolution.

Even in this vicinage I don't know that we understood Gaudier's " Vortex." I mean we, a few of us, saw that it was a damn fine piece of writing, tremendously condensed. But if he had then heard of Frobenius, he was the only man in London who had, and, as nearly as I remember, he had forgotten the names of the authors of whatever he had read about art's archaeology.

But you can't even now get an English translation of " Erlebte Erdteile," or even of " Paideuma," and if you could there would still be more of Frobenius' essential knowledge in Gaudier's four pages than would go into any translator's forty.

" Sculptural feeling is the appreciation of masses in relation."

" Sculptural ability is the defining of these masses by planes." And that was 1914.

We have gradually learned that the best African sculpture is conceived as a mass, and that inferior sculpture has been seen as silhouettes in succession.

Epstein was already talking about form. And in twenty years I suppose a number of people have gradually got round to understanding the apparently simple and apparently platitudinous statement that a sculptor *expresses* his meaning *by* form.

A sculptor is a bloke that cuts stone (with the kindred arts of modelling in clay or wax and having bronze cast into forms). Mr. Adrian Stokes has thought a great deal about sculpture, about carving, modeling, meaning, but he is not thereby a sculptor.

People will sometimes admit this, but I am not wasting either your time or my own, when I try to induce you really to think about this distinction.

For eighteen years after Gaudier's death no one showed the least chance of succeeding him. Epstein had already done his most satisfactory work, and Brancusi alone continued the conquest of marble. Brancusi alone continued to use form to express a reality with greater precision, with greater knowledge than his contemporaries or predecessors had possessed.

Cubism has not decayed. Concepts do not decay, but inferior minds and inferior artists waddle about in dilutions of concepts, and exchange weak or faulty imitations.

Gaudier's meaning is expressed in his work. There is no use in anyone's thinking they can explain that meaning by mere talk about the work. If you can't get to the actual three dimensional objects, the photographs will give you an approximate idea of his *meaning,* as they give you an approximate idea of his work. It is even possible that a well meaning spectator with limited perceptions could study a statue by photographs, as he might find a dictionary useful in studying a foreign language. Stokes' photos, in his " Stones of Rimini," may help a man who has seen the original to see *more* of it. But no one will ever see all of it from the photos. Neither will the present reader get the full measure of the distance between Brancusi and Gaudier and inferior sculptors merely from looking at photos.

Any more than you can get an idea of Dante by reading some bloke's essay about him.

John Cournos said at the time (1914):

" Gaudier's Vortex is the whole history of sculpture.' It is also the history of Kulturmorphologie, it is also . . . (and herein

is the justification of my writing a new article on the subject), it is also the proclamation of a new birth out of the guttering and subsiding rubbish of 19th century stuffiness. A volitionist act stretching into the future. The " fall of impressionism," the " Untergang " you can't call it sunset, but the moon-set or the slopset of a period that had included the whole three or four preceding centuries, in which expensiveness had usurped the place of design.

It meant a complete revaluation of form as a means of expressing nearly everything else, or shall we say of form as a means of expressing the fundamentals of everything, or shall we say of form as expressing the specific weights and values total consciousness?

Or would it be better to say simply " form as a means of expression?"

At any rate it was three dimensional assertion of a complete revaluation of life in general, of human life in particular, of man against necessity, by which I include social and physical necessity and there is, of course, in the long run no social necessity. What we call social necessity is nothing but the temporary inconvenience caused us by the heaped up imbecilities of other men, by the habits of a dull and lazy agglomerate of our fellows, which sodden mass it is up to the artist to alter, to carve into a fitting shape, as he hacks off unwanted corners of marble.

In this field Gaudier did his bit. Magnificently did it, in two or three years, getting rid of no end of superfluous nonsense in his immediate field, which was perhaps fifty dollars worth of marble, and ten dollars worth of paper and ink. (I am here making a maximum estimate.)

There is still enough energy even in what I was able to get into my memoir of his (i.e. all his own writing and 40 half-tone reproductions) to modernize Russia, to bring communism to date, I mean into harmony with the best thought of the occident, and to make America fit to live in. By modernizing Russia I mean that the trouble with Russia is the trouble with a smoky locomotive. When they get to dividing the cultural heritage, and to seeing that this heritage is the actual source of value they will have arrived at a state of understanding which will make them good neighbours even though Russian. And if we could do like-

144

wise we would also be good neighbours for them.

People talk about " abstract sculpture " without realising the various degrees of abstraction which can obtain and have obtained in great sculpture. We will never have active sculptural criteria until more critics understand the extent to which a good sculptor " abstracts " form, takes form from natural objects, and puts it together again in his work.

Gaudier's Vortex was so brief that very few people saw its profundity. John Cournos saw that it contained the whole " history " of sculpture, but it also contained pretty much the whole " Euclid." I mean the whole layout of the fundamentals. The real sculptor " sees " or is aware of, not only all the sides of his work, but of the " through," that is the diameters that can be passed through it from any angle.

Plates XIII, XXIX, Hieratic Head of E.P. The only large block of marble Gaudier ever had at his disposal. The work represents two months' actual cutting, and was preceded by a hundred drawings, many of which could be recognized as portraiture, and any one of which might serve as sculptural education. Like Henry James' prefaces, they indicate what the artist has in his head before he starts on the final manifestation.

PEREGRINATIONS, 1960

Remy de Gourmont wrote the first French acknowledgement of Gaudier's existence, a brief obit labelled " Maçon ", which had been Gaudier's answer on the army form re his profession.

The British press commented on his death notice in the second issue of *BLAST* by remarking that it was carrying a joke too far to print obits of " these invented mad men."

The big bust remained in Violet Hunt's front garden on Camden Hill, its presence recorded in Douglas Goldring's admirable " South Lodge ". As no one could afford a pedestal the slugs and the lawnmower left their record. Child, Violet's marvelous old retainer having been asked for pail and scrubbing-brush and then interrogated as to the ubicity of the guest and unknown friend for whom the art work was being furbished, reported :

" Mr. Peaound iz ine garrden a-scrubbin his MONUMENT." (end quote.)

Finally there was sufficient cash balance to achieve transfer to the Gulf of Tigullio, and for some years the marble stood by my lunch table, ground floor of Majerna's Albergo Rapallo. (documentation can be furnished if desired.)

After Majerna had reported Abyssinia full of animals, and rejoiced at having ceased vegetation, and then been ousted from proprietorship by one of the dirtiest small wangles that marred the second fascist decennio, one risked the structural firmness of the restored Palazzo Barratti (then No. 12 via Marsala) stretched some large planks over what were presumed to be rafters, and the stone eyes gazed seaward.

After wars and permutations it went to Brunnenburg, and thence to the Milan memorial show, to one in Merano, and to present home with a wall for the charcoals, and the company of Cat, Boy with Coney, a Nina, and other pieces in Brunnenburg.

The Milan show having been contemporary, to the extent of Italians hoping to meet the new sculptor and writing to say so. Olivia Rossetti Agresti was, by parallel, asked to sign a copy of the Divina Commedia in Chicago, the confusion between her

uncle Dante Gabriel R. and D. Alighieri not having been cleared in the capital of Illinois.

The remarkable Scheiwiller issued a booklet and, I suppose, guided the two excellent Italian catalogues, though those of the London and French shows were in larger format.

Brunnenburg, Tirolo, 1960.

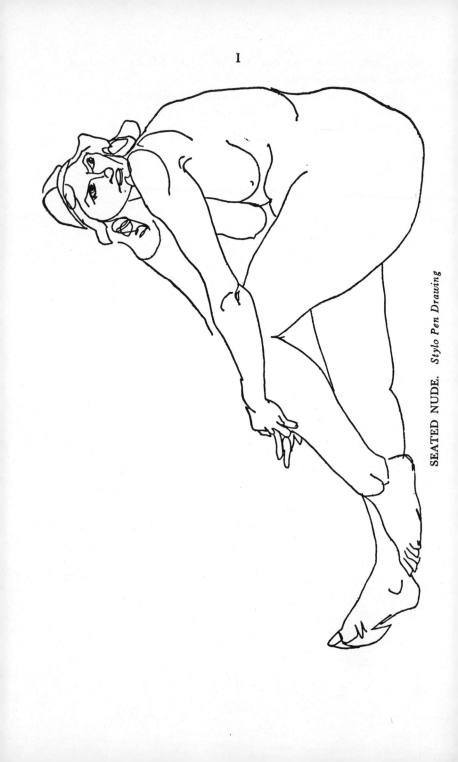

SEATED NUDE. *Stylo Pen Drawing*

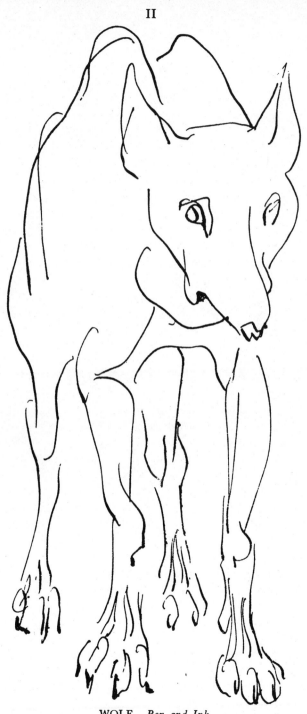

WOLF. *Pen and Ink*

EQUESTRIAN. *Pen and Ink.*

CAT. *Pencil*

LION. *Pen and Ink*

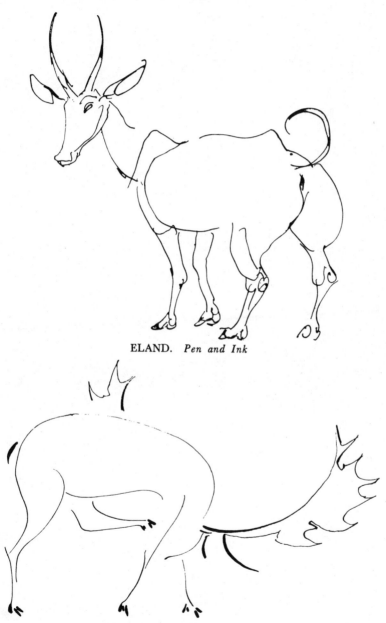

ELAND. *Pen and Ink*

STAG (*in the* Chinese manner). 1913.
Pen and Indian Ink

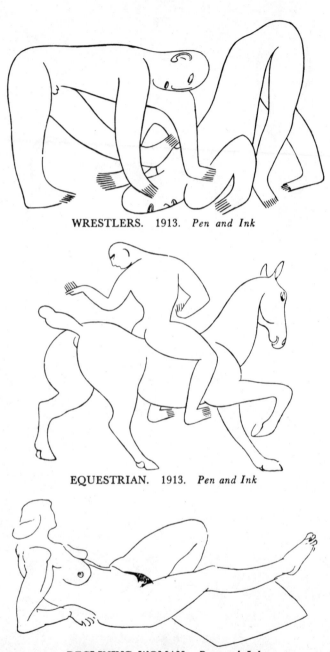

WRESTLERS. 1913. *Pen and Ink*

EQUESTRIAN. 1913. *Pen and Ink*

RECLINING WOMAN. *Pen and Ink*

VIII

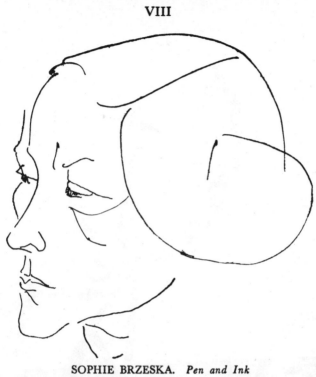

SOPHIE BRZESKA. *Pen and Ink*

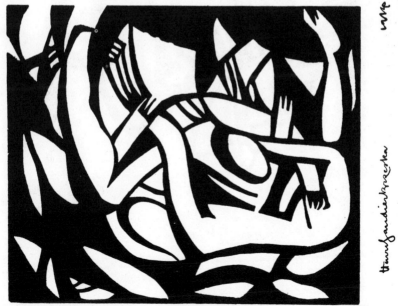

LINO-CUT

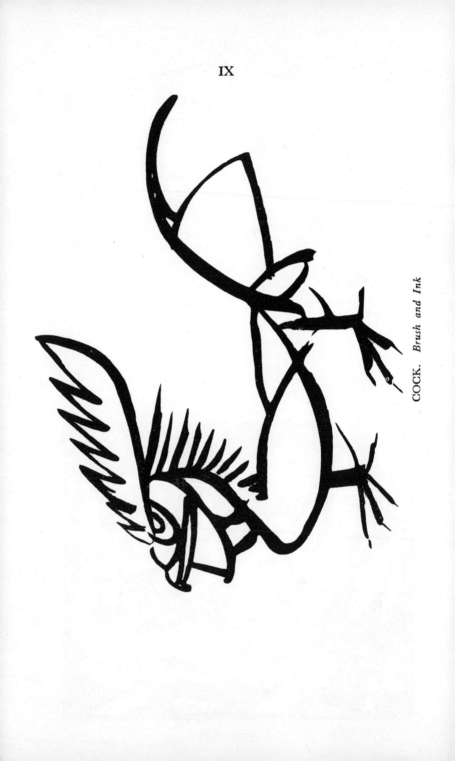

COCK. *Brush and Ink*

X

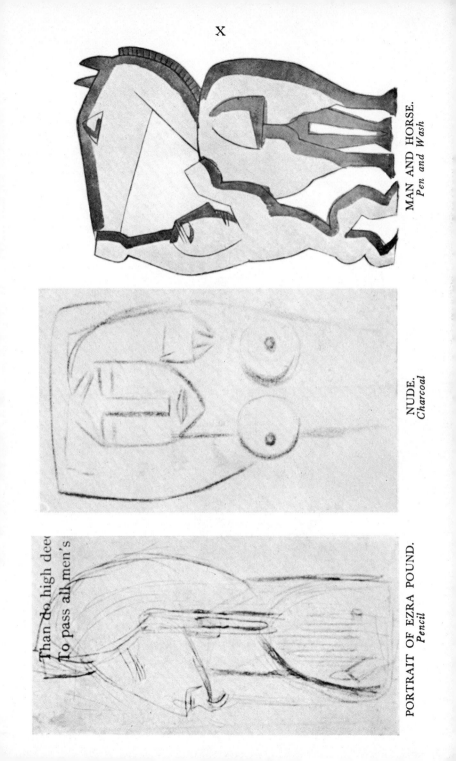

MAN AND HORSE.
Pen and Wash

NUDE.
Charcoal

PORTRAIT OF EZRA POUND.
Pencil

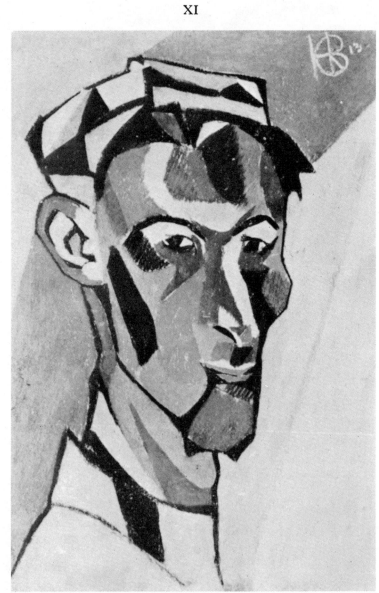

SELF-PORTRAIT. 1913. *Pastel*

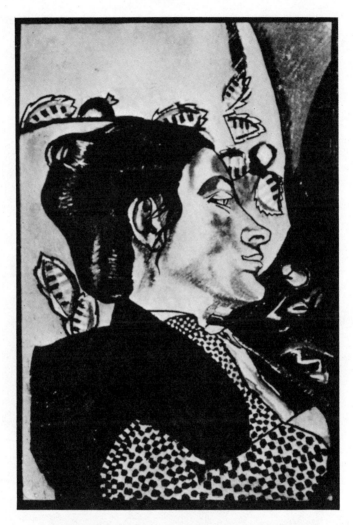

MADEMOISELLE BRZESKA. 1913. *Pastel*

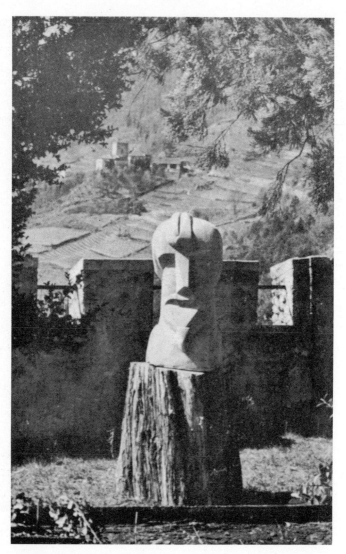

HIERATIC HEAD OF EZRA POUND (A). Marble 1914.
Shown in its present surroundings; the gardens of Brunnenburg

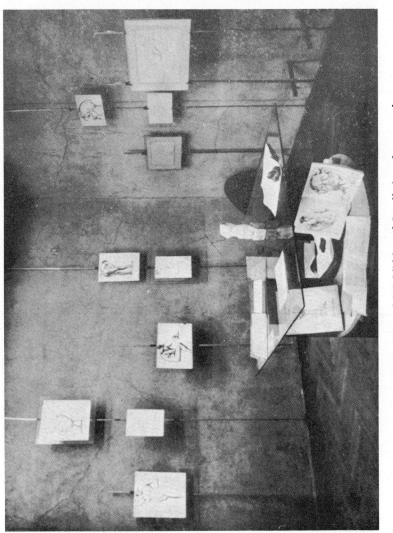

A section of the Memorial Exhibition of Gaudier's sculptures and drawings at Milan in 1957.

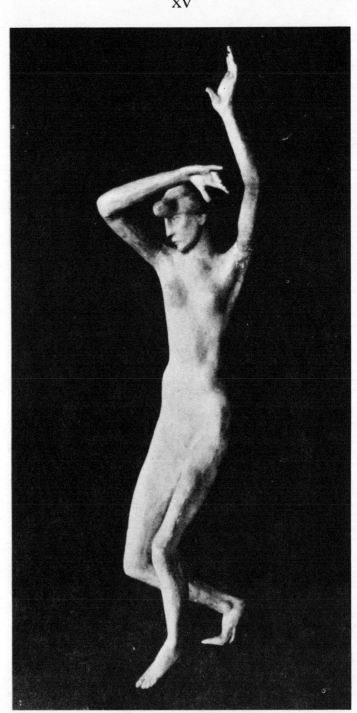

THE DANCER. *Bronze* (A)

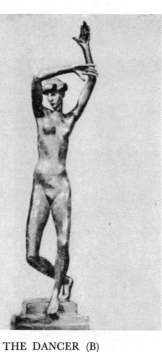

THE DANCER (B)

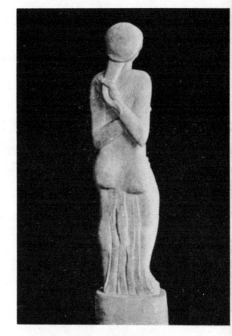

THE SINGER. 1913.
Derby Stone

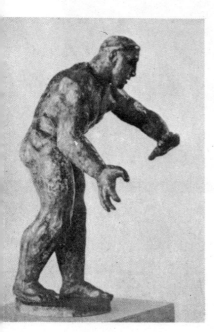

THE WRESTLER. 1913.
Lead

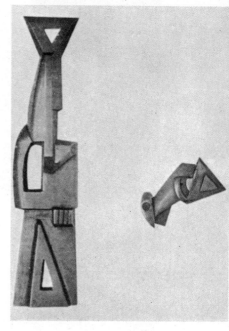

TOY and FISH.
Cut Brass

XVII

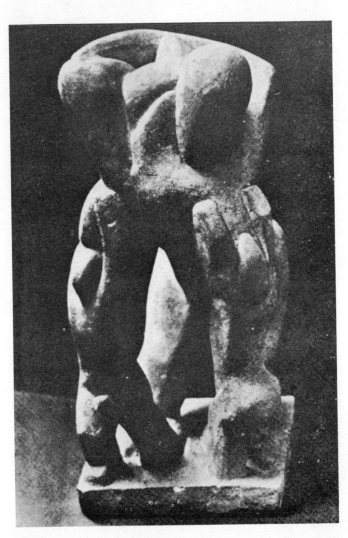

CARITAS. *Stone*

XVIII

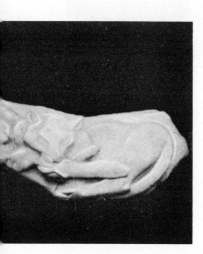

CAT. *Marble*

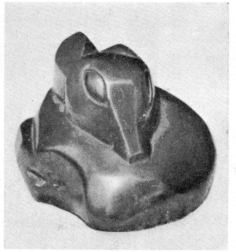

FAWN. *Bronze*

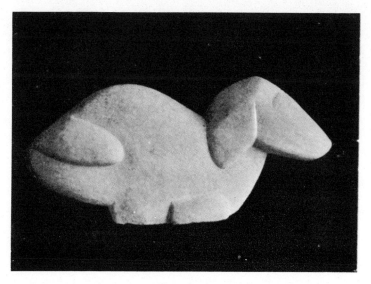

DOG. *Marble*

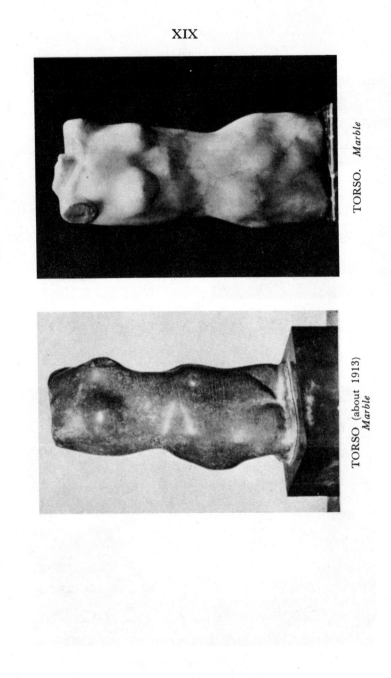

TORSO. *Marble*

TORSO (about 1913)
Marble

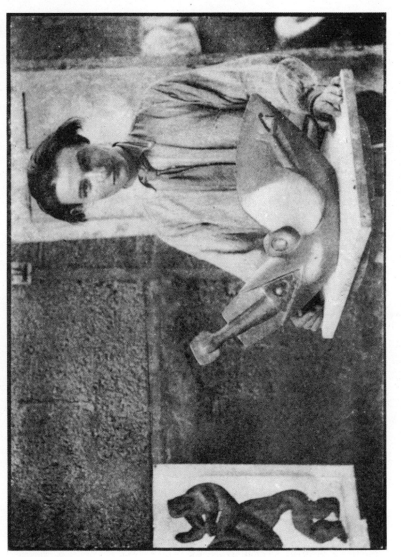

Gaudier standing behind 'BIRD SWALLOWING FISH'

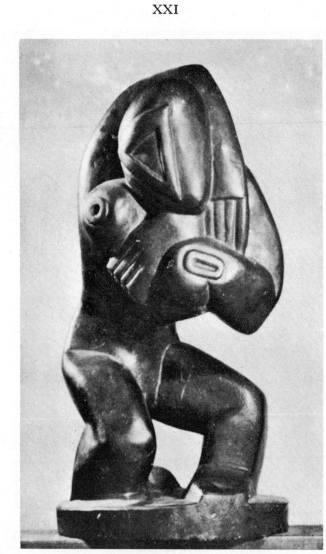

RED STONE DANCER. 1913. (A)
Mansfield Sandstone

XXII

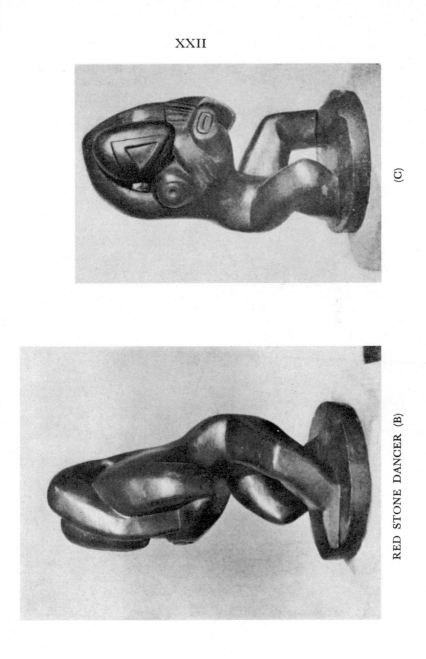

(C)

RED STONE DANCER (B)

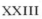

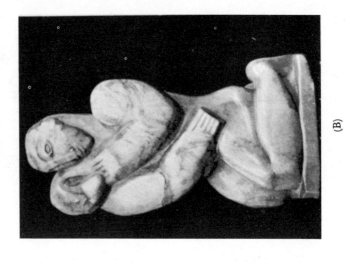

(B)

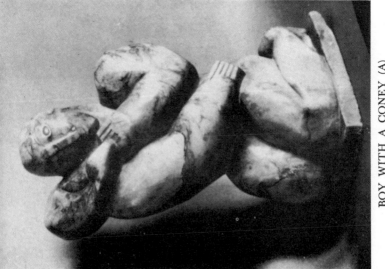

BOY WITH A CONEY (A)
Veined Alabaster

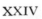

XXIV

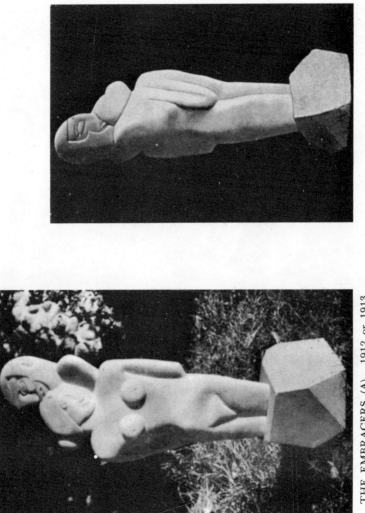

(B)

THE EMBRACERS (A). 1912 or 1913.
Marble

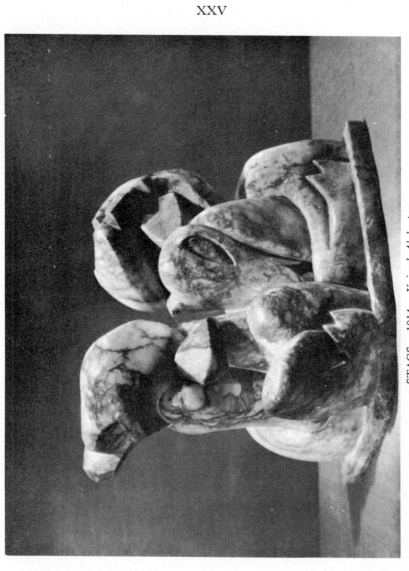

STAGS. 1914. *Veined Alabaster*

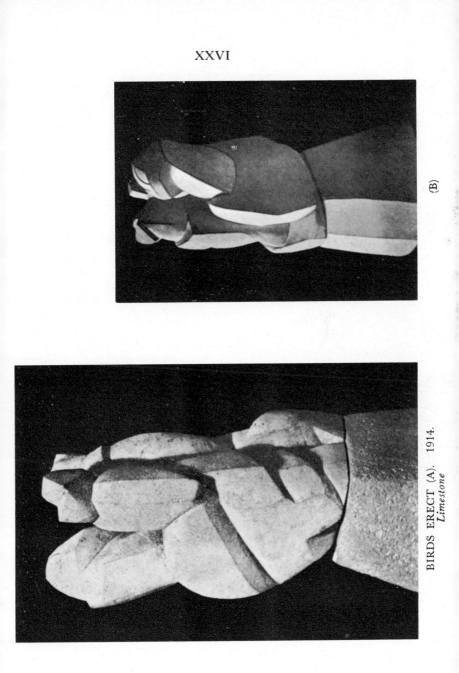

(B)

BIRDS ERECT (A). 1914.
Limestone

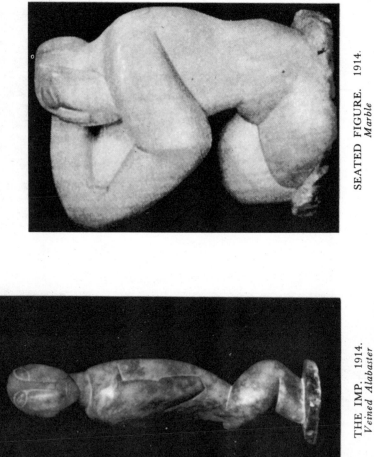

SEATED FIGURE. 1914.
Marble

THE IMP. 1914.
Veined Alabaster

GAUDIER-BRZESKA

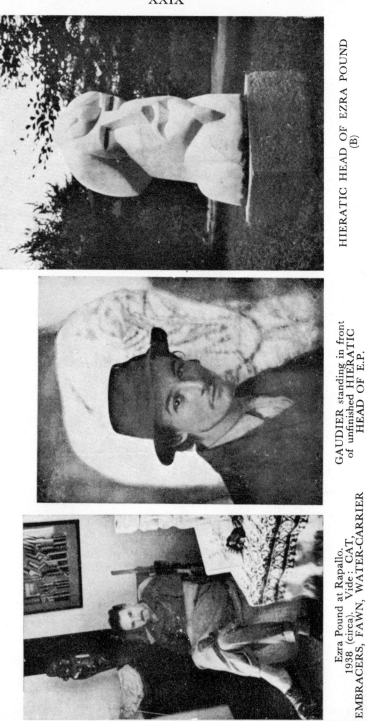

HIERATIC HEAD OF EZRA POUND (B)

GAUDIER standing in front of unfinished HIERATIC HEAD OF E.P.

Ezra Pound at Rapallo, 1938 (circa). Vide: CAT, EMBRACERS, FAWN, WATER-CARRIER

Lundi 28 Sept 1914 - Dear Ezra - je reviens d'un enfer d'où peu échappent - avant hier dans la nuit ma Compagnie a opéré une attaque contre la route où des prussiens étaient installés nous y sommes allés à la bayonette - puis nous nous sommes fusillés d'abord à 50 m - ensuite d'un bord du talus de la route à l'autre où les alboches se tenaient - j'en ai vu deux montrer la tête et je les ai envoyer au paradis - mais partis 12 de mon escouade nous nous retrouvons aujourd'hui 5 seulement je t'écris du fond d'une tranchée que nous avons creusée hier pour se protéger des obus qui nous arrivent sur la tête régulièrement tout les cinq minutes - je suis ici depuis une semaine et nous couchons en plein air - les nuits sont humides et froides et nous en souffrons beaucoup plus que du feu de l'ennemi - nous avons du repos aujourd'hui et ça fait bien plaisir - donne mes civilités à Mrs Shakespeare à Richard et sa femme et bien à vous deux

Henri Gaudier

Letter from Gaudier-Brzeska to Ezra Pound.
28th September, 1914

GAUDIER-BRZESKA in uniform (bottom row,
second from left). 1914 or 1915